# *Big Brush* WATERCOLOUR

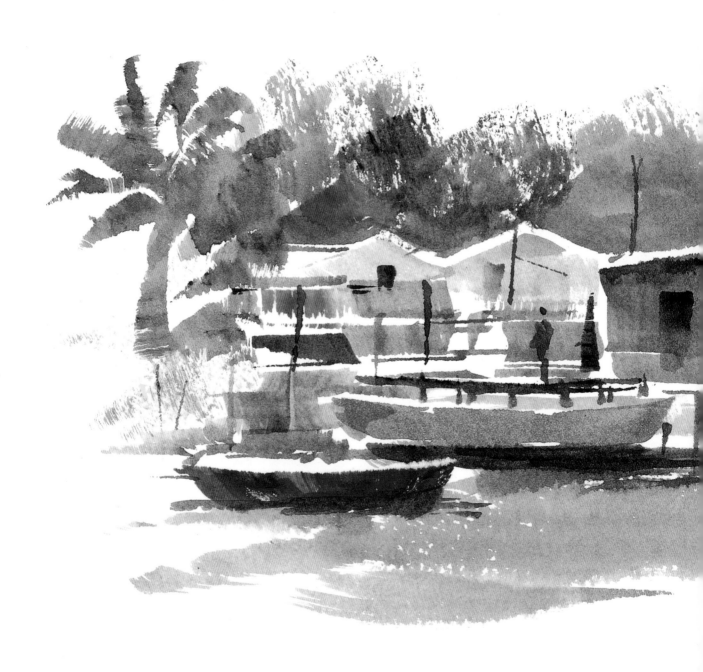

# Big Brush
# WATERCOLOUR

## RON RANSON

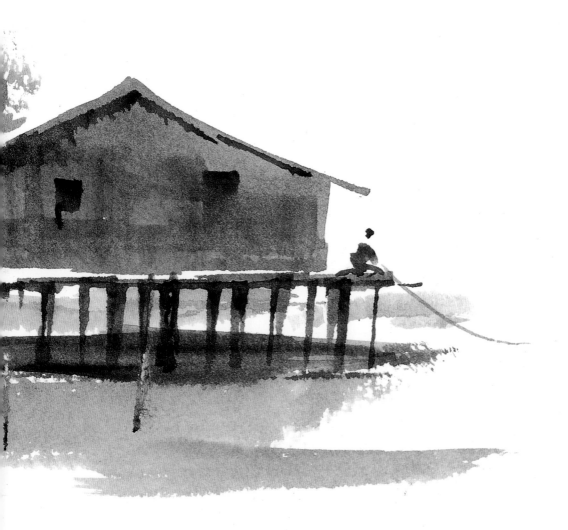

David & Charles

A DAVID & CHARLES BOOK

First published in the UK in 1989
First paperback edition 1996
Reprinted 2003

A catalogue record for this book is available from the British Library.

ISBN 0 7153 9301 4 hardback
ISBN 0 7153 0195 0 paperback

Printed in Hong Kong by Wing King Tong Co Ltd
for David & Charles
Brunel House    Newton Abbot    Devon

Visit our website at www.davidandcharles.co.uk

David & Charles books are available from all good bookshops;
alternatively you can contact our Orderline on (0)1626 334555 or write
 to us at FREEPOST EX2 110, David & Charles Direct, Newton Abbot,
TQ12 4ZZ (no stamp required UK mainland).

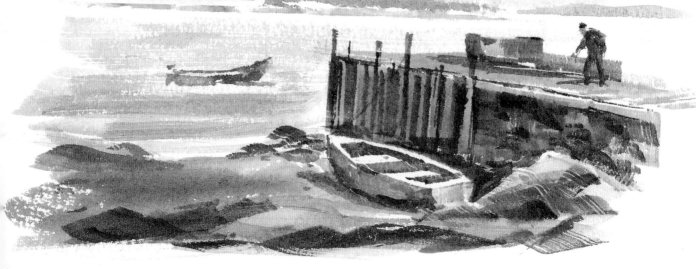

# Contents

## ACKNOWLEDGEMENTS

I try to do as much of the book as I can at home, and I would like to thank each of my friends and neighbours who have assisted me: Janet Broughton and Liz Randolph who have deciphered and typed my scribble; Ann Mills for helping me edit it; Ray Mitchell for the photography, and his daughter Karen for working with me on the layout.

## ABOUT THE AUTHOR

**Ron Ranson** is a bestselling author and artist whose work has been exhibited in Europe, the United States, Australia and South Africa. He also enjoys a worldwide reputation as a tutor, and runs residential courses and summer schools. He is the author of the bestselling practical book *Watercolour Fast & Loose* as well as two successful volumes on the watercolourist Edward Seago and the outstanding collection of modern painters, *Watercolour Impressionists*. Ron lives in Gloucestershire.

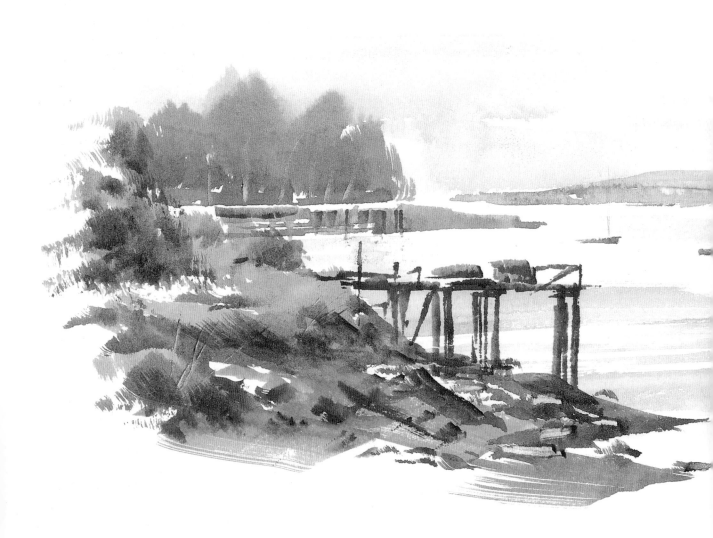

# Introduction

Here I am starting my third book on watercolour. Each time I finish one I think, 'Well that's it, I've said all I've got to say about the subject'. Then a year or so and a few hundred students later, I feel another book coming on. One thing that encourages me to keep writing is the number of letters I receive beginning 'I don't usually write to authors, but yours is the first book on painting I've read from cover to cover in one sitting'.

Leisure painters, as a breed, love art books and can never resist rushing out to buy the latest offering. They spend many an hour poring over the glossy colour pictures but usually flick through what they feel are the boring pages of text on such subjects as composition and tonal values. 'We've heard all that stuff before,' they say with a yawn, and put the book on the shelf with all the others, to be dipped into occasionally when they want some pictorial inspiration for the next art society meeting. They then eagerly await the next offering from the publishers, which, they hope, will magically turn them into better painters without too much effort on their own part.

I know all this because I'm a bit like that myself, and many of my students reluctantly confess they're like this too. What we don't realise is that it's these so called 'boring' bits that are really the key to making us into more competent artists. My present aim, therefore, is to try and hold your attention by making my books as interesting as possible throughout—I've even tried to put a picture on every spread to stop you skipping anything, all in the cause of holding your interest.

Another thing to remember, and something I realised a long time ago, is that success in painting is not a God-given gift; it's almost always due in the end to dour perseverance. I'm afraid there's absolutely no substitute for practice and still more practice. No amount of reading of art books alone will get you there. There are no short cuts, you have to damn well work at it! Those envious words 'He or she has a gift for it—I wish I had it' drive me mad. That 'gifted' person has probably worked for years to become so skilled.

Looking over a class of students, I can usually tell the ones who are going to make it. There's the usual proportion of social painters, bless them, who are there because they enjoy the fellowship and company of nice people (painters are always nice people!), and happily turn out similar work year after year. Then there are those who worry their painting problems like a terrier with a rat. On my courses, they're the ones who are up painting before breakfast, and often still at it at 10.00pm when the rest are at the pub. They may not be the most talented ones

at the beginning, but they're usually the ones who, eventually, get their work in the big exhibitions, and often start their own classes.

Something you have to avoid, is getting depressed if the quality of your work doesn't progress continually upwards. Regression happens to us all. I often get the feeling myself that I was turning out better work two years ago, forgetting all the rubbish I was producing then. One tends only to remember the highlights, like the summers of our youth. Remember, your critical faculties will have progressed too; maybe faster than your painting skills. A painting you were quite pleased with then, you now reject.

I really believe that the only students who don't make it are those who drop out because they can't take a bit of failure. A painter's life will always alternate between elation and despair; it's part of the game. I've ruined hundreds of sheets of perfectly good paper, and am prepared to ruin thousands more in my struggle to gain knowledge and skill.

Many of you may be starting painting late in life as I did. Having been in industry for most of my working life, I lost my job at fifty and like most of you never had time for any formal art training, so I had to try and teach myself from scratch. I was, however, lucky enough to find a thing called a Hake Brush, which nobody else seemed to have bothered with, but which had an enormous influence on my approach to painting, and later, teaching. So what is so special about this hake? It makes no claim to turn you into a great artist overnight, in fact, in the beginning you'll probably hate it, but what it will do is stop you blindly imitating nature in all its detail. It forces you, by its very size, to simplify things, and gets you away from the poky little brushes that are an absolute invitation to fiddle and overwork your paintings. I regard it as a symbol of freedom—read on!

BELOW
*This loose, almost abstract, painting
was produced in about ten minutes.*

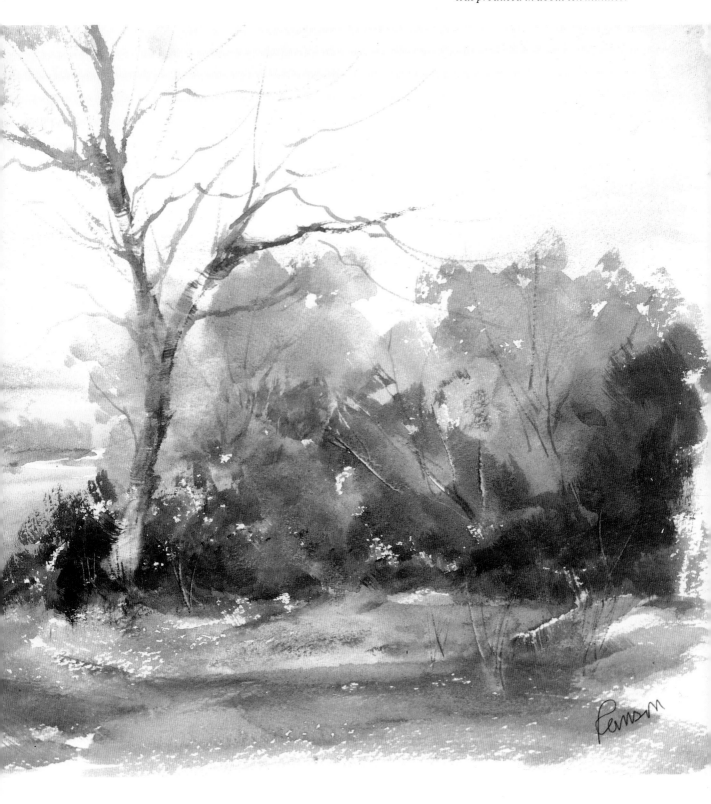

# Distilling the scene

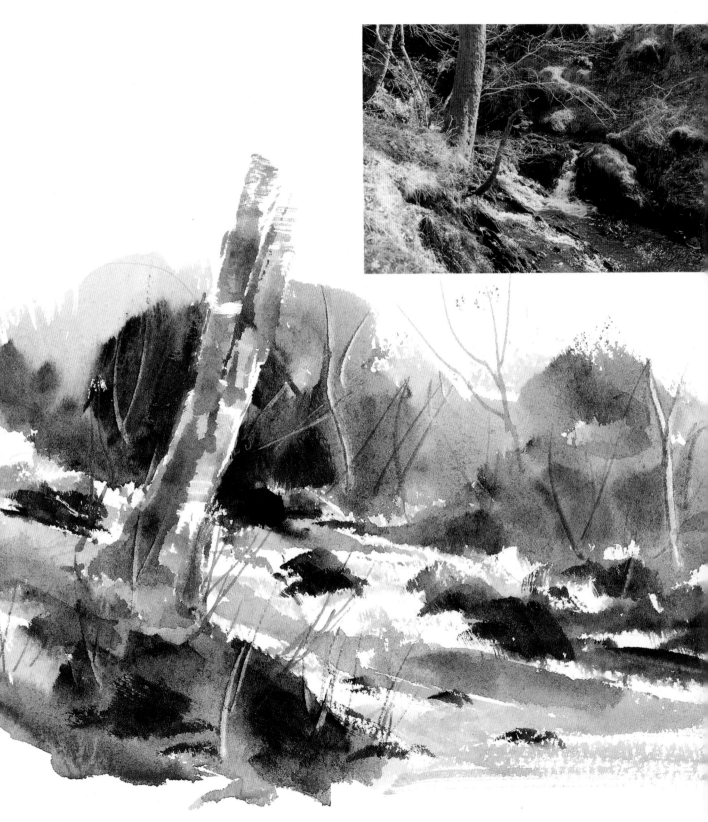

*This is a tiny stream I found in Scotland. What I'm trying to show you here is how to get the essence of the scene by leaving out the superfluous clutter.*

When we first start painting we go around to various scenes, earnestly trying to copy what's in front of us as accurately as we can. We're all much too busy wrestling with the many problems of handling our tools and mixing our colours to worry about being 'creative'. Whether we're working out in the open, or from photographs or sketches in the studio, the result is usually the same—cluttered, rather anonymous, and from the artistic point of view rather sterile. We may go on for years at this stage, particularly if our pictures start to sell, and our customers want to know exactly where any particular scene was located. You could call it a carbon-copy approach to painting.

Please believe me, I'm not in any way decrying this particular stage, as long as you realise it is only a pathway to your further development as an artist. It's a very necessary part of learning your craft, using tools and gaining confidence. The only trouble is, that so many painters never get beyond this stage. If you continue for years to describe every leaf on a tree and every blade of grass, you'll never achieve anything that countless other artists can't do just as well.

Now we come to the real purpose of this book, which is either to lead or push you into the next stage or, in football terms, to get you from the Second Division into the First. First of all, I've got to convince you, somehow, to change completely your attitude to your paintings. Forget about just reproducing nature, and start re-arranging it. Realise, that as an artist, you have the power to select or reject. Use the scene before you only as a starting point.

The trouble with nature, is that it's full of interesting things that clamour for your attention, rather like a Property Room in a theatre. It's up to you to select the relevant items you need, rejecting the superfluous, and re-arranging them on stage to produce a powerful and significant scene. An exquisite and sought-after phial of perfume is the final result of the skill put into the blending and distillation of large quantities of many other, perhaps not so pleasant, ingredients. It's only created after infinite thought and expertise. Think also, of a mother bird feeding her young. She feeds them a pre-digested version of the whole. It's your job as an artist, to pre-digest and provide the viewers of your picture, who perhaps, do not have your perception, with a distillation of the scene, containing the spirit and emotion which excited you enough, in the first place, to want to capture it on paper.

Have I managed to convince you? Are you ready to come with me into the First Division? I know, from bitter experience,

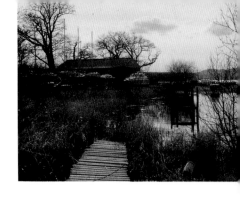

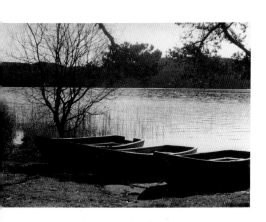

*In this peaceful lochside scene I felt one boat was enough to provide a focal point, and considerably reduced the tone of the background to give greater recession.*

how difficult it is to try and make students spend more time on preparation, before they start their actual finished painting. This preparation is absolutely a key factor, yet so many students seem to regard it as a boring nuisance—all they want to do is to get on with the painting itself, yet this mental barrier is the first you'll have to get over if you are ever going to progress as an artist.

During the short time you have to work on a watercolour, you'll face many immediate and simultaneous decisions; the drawing itself, the composition, the tones, the texture and the mixing of the colours, all of which you have to make with authority. What I'm saying is, that to have any real chance of tackling all these problems successfully in the time, you *must* plan ahead before you start. Without this planning, your painting will probably be indecisive and fragmented, and you'll try to say too much in one picture.

Professional painters know this, and do it automatically. They probably spend more time planning a watercolour than actually working on the finished painting. However, most amateur painters don't give planning a thought. They leap into a large piece of

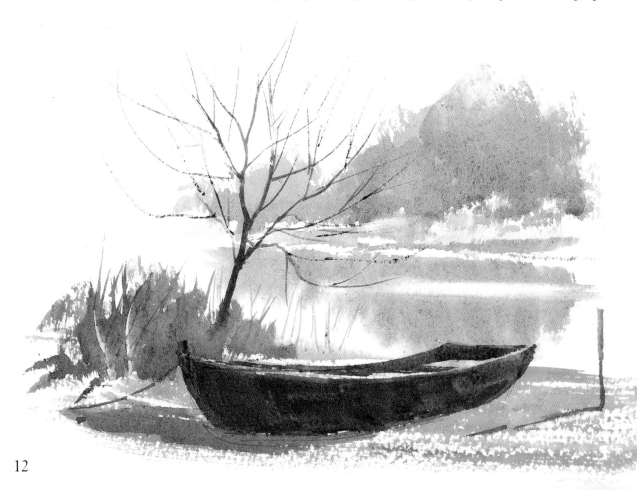

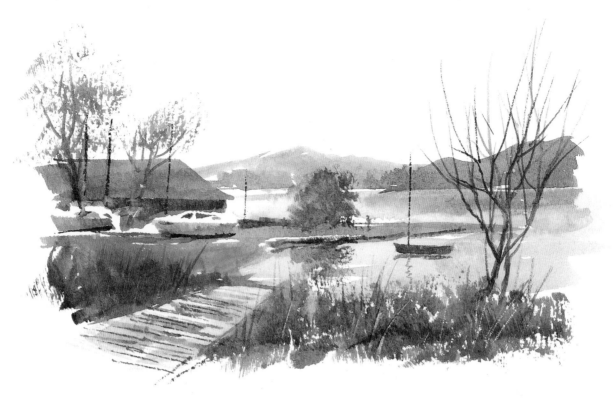

ABOVE
*This was an interesting but very cluttered scene. Notice I've changed the direction of the duckboards to take the eye into the picture, and counterchanged the stored boats against the boathouse. The background hills are reduced in tone to give more feeling of distance.*

paper quite blindly, struggling to work out the various problems as they go along.

In my previous two books, I've written a lot about simplification, but we are not talking here about the simplicity of a child's painting, formed really by lack of knowledge. Our simplicity can only be achieved by forethought, planning and insight. It actually takes much more effort to create a bold simple painting, than to endlessly worry and poke a picture to death.

It should, now, be pretty obvious why it's always easier to copy someone else's painting, rather than work on site or even from a photograph. All the selection, rejection and design have already been done for you.

Part of your planning will be to decide where you are going to paint. There are advantages and disadvantages to painting both outdoors and indoors. Outside, you may feel more inspired by the subject matter, even the sounds and smells may help, but these can also be a distraction, as can the confusion and over-abundance of material. The vagaries of our weather don't help either. Rain, wind and sun all present problems. As I said in my first book, there seems to be no such thing as perfect conditions for watercolour artists.

By painting inside the studio, you'll certainly avoid many of these distractions, and you'll be able to paint just as easily at 11 o'clock on a winter's night, as on a summer's morning. Here, however, the main problem is the source of material to work from, but you can, of course, use sketches or photographs. These are perfectly satisfactory, as long as you apply the same rules of selection and rejection as when you work outside (more about this later)—see pages 40-45.

Lastly, may I plead with you to thoroughly read and digest Chapters 5 and 6, which I believe to be the most important parts of this book.

# The equipment

It seems that every self-respecting book on painting has to have a chapter on materials, but I'll try to make this as brief as possible. Amateur painters in general, in addition to continually looking for that magic art instruction book that will immediately turn them into successful artists overnight, also scan the pages of the monthly art magazines for new products, which the advertisers swear will make painting easier, and even make up for lack of skill. The list is endless,from pencils, which when wetted will enable you to produce watercolours instantly, to the ultimate aid, where all you have to do is carefully paint in numbered shapes on a printed board to achieve a masterpiece.

I, too, have been seduced in my time by various gadgets, but I thought I'd got over it. However, in the past few months, I've gone completely crazy, and taken over an art shop, which is really like a drunkard buying a brewery. Despite this, my whole philosophy is to ruthlessly cut materials to the bone. If you accept this, it will hopefully enable you to concentrate your skills, or potential skills, on handling as few tools and colours as possible.

Let's talk about brushes. Firstly, the cornerstone of my approach to watercolour and the reason for the title of this book, the hake. This is a traditional Japanese watercolour brush with a long wooden handle, into the top of which goat hair is stitched. I've been using the 2in size for many years now, and it has formed the basis of my own simplified technique. The trouble is it takes a lot of 'wearing in' and tends to be rather fluffy and uncontrollable at first, especially with beginners. However, I've now got the answer – an English brushmaker called Pro Arte, after watching me paint, has designed and produced a range of three 'pre-trained' hakes which are much more amenable to use, even when they're new.

But why use such a crude looking implement, when you could buy a nice shiny-handled sable brush with a sharp point that springs back into the shape instantly? The answer, for me, is that, by its very nature and size, it forces you out of that dreadful fiddling and overworking that affects so many of us, and makes you paint in a much more impressionistic style, so that you are able to say in one stroke what took ten to say before.

That's the good news. The bad news is that it still takes quite a bit of getting used to and you'll probably hate it at first. The main trouble is that it holds large amounts of unseen water if you insert the whole brush in your water-jar. To avoid producing weak, drippy paint, the secret is to first remove most of the water by touching a sponge or rag, before mixing your colours.

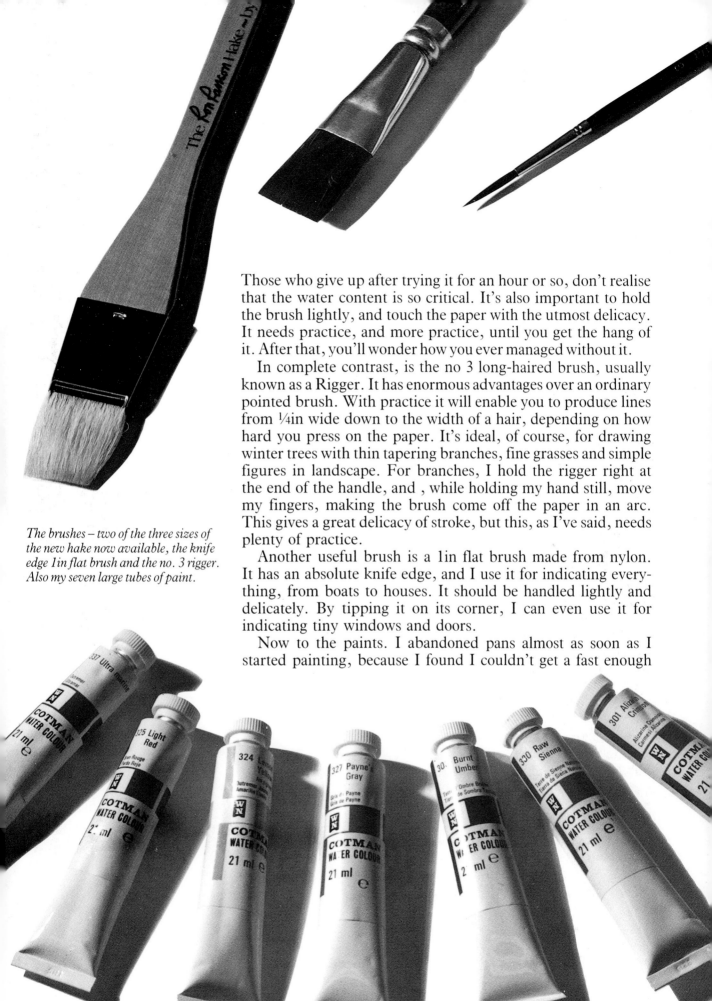

Those who give up after trying it for an hour or so, don't realise that the water content is so critical. It's also important to hold the brush lightly, and touch the paper with the utmost delicacy. It needs practice, and more practice, until you get the hang of it. After that, you'll wonder how you ever managed without it.

In complete contrast, is the no 3 long-haired brush, usually known as a Rigger. It has enormous advantages over an ordinary pointed brush. With practice it will enable you to produce lines from ¼in wide down to the width of a hair, depending on how hard you press on the paper. It's ideal, of course, for drawing winter trees with thin tapering branches, fine grasses and simple figures in landscape. For branches, I hold the rigger right at the end of the handle, and , while holding my hand still, move my fingers, making the brush come off the paper in an arc. This gives a great delicacy of stroke, but this, as I've said, needs plenty of practice.

Another useful brush is a 1in flat brush made from nylon. It has an absolute knife edge, and I use it for indicating everything, from boats to houses. It should be handled lightly and delicately. By tipping it on its corner, I can even use it for indicating tiny windows and doors.

Now to the paints. I abandoned pans almost as soon as I started painting, because I found I couldn't get a fast enough

*The brushes – two of the three sizes of the new hake now available, the knife edge 1in flat brush and the no. 3 rigger. Also my seven large tubes of paint.*

response from them. I needed to be able to put my brush into a juicy rich pile of paint, and use it instantly. To get over this awful meanness we all seem to have when we get out our paints, I started to buy large tubes of good-quality students' paint. Not that I've got anything against the very top-quality paint, but I do find so many people are inhibited by the extra expense and invariably use too little.

Something else I did right at the beginning was to reduce my colours to as few as possible, known in the trade as a 'limited palette'. I now use only seven colours, which I find quite sufficient for my needs. Because there are so few of them, mixing soon becomes almost instinctive. By the way, you'll see there are no greens in the list—I hate made-up greens! My colours are: Raw Sienna; Cadmium Yellow; Burnt Umber; Ultramarine; Light Red; Alizarin Crimson; and Paynes Grey. Later in the book, I'll show you how to mix these to get practically any colour you'll need.

As for the palette, it obviously needs to be large enough to cope with my hake and big tubes of paint. I also like to have plenty of room to move my paint about, so I bought a white plastic tray from a hardware shop, and found this ideal. It was so cheap, I could buy quite a few of them. These stack up

*This is my idea to try and make students do simple value sketches before they start their paintings – three spirit markers of different tones of grey, and a little ringbound sketchbook. The wide felt tips also prevent too much detail.*

compactly, are light to carry around for outdoor painting.

Now to paper. I always use 140lb Bockingford paper, which is thick enough not to cockle when wet. I use it in handy wire-bound books containing twelve sheets with a cardboard backing. I must admit that I've never stretched a piece of paper in my life, although lots of books seem to spend pages showing you how to do it. Paper expands when it's wet, but because it's often taped or pinned down it's not allowed to, so it has to cockle in protest. With a wire-bound book it can expand and contract freely. I do have a spring clip which I move round to strategic points on the loose edges of the painting as I work. Hand-made papers are lovely to use, but because they're so expensive, they can be very intimidating for a student.

Those are really all the actual painting materials. The only other thing I use is a metal easel, made in Italy. It's very stable and easy to adjust, and has a built-in hook, on which I hang my collapsible Japanese water-pot. The latter is made of plastic and looks like a Chinese lantern. All this, apart from the easel, is carried round in a fisherman's plastic box. Although not strictly painting material, I try and encourage my students to produce tonal value sketches before starting their finished work (something I almost have to drag them, kicking and screaming, to do). I've recently devised a cunning little kit, which comprises a very small spiral-bound drawing pad containing cartridge paper, and three spirit markers, a pale grey, a mid grey and a dark grey. With these you can produce simple bold results almost in seconds. The wedge-shaped markers will force you to simplify, and the results can be very exciting in their own right. (See page 31 for some work done with them.) A warning though; replace the caps as soon as you've used them or they'll quickly dry up. So you see, I really do practise what I preach — the less clutter the better!

*My large plastic tray – I've got about a dozen at home that stack together – and the ringbound pad of 140lb Bockingford paper. This one is 12in x 16in.*

# Making the brushes behave

Let's start by saying that all the technique in the business won't guarantee you success as an artist, any more than painstakingly learning every tennis stroke will automatically get you to Wimbledon. You can only be sure you won't get there without them!

Students are often excited and deceived at an art-society demonstration by professionals who quickly, and apparently without much thought, produce a fresh painting in front of their very eyes. They go home thinking, 'If only I could use that special sweep of the brush, I could be just as successful.' There is, I'm afraid, much more to it than that. If you were to buy a special fountain pen, for instance, and slope your writing the same way as Jeffrey Archer, you wouldn't automatically turn into a best-selling novelist. In the same way, the manner in which you flourish your brush has little to do with the expressiveness and sincerity of the resulting picture.

Confident handling means that you get a very direct application of paint on paper and this produces a freshness and sparkle of colour, giving a spontaneous look to the picture. However, this quality, which enthralls us all, can only really be achieved with a thorough knowledge of tone, colour and form. Slickness of application can even be detrimental to a student's work if it's not backed up with soundness of construction, or artistic sincerity. An experienced artist looking at such work will immediately see through the bravura into the emptiness beyond.

What a way to start a chapter on techniques by trying to disillusion and depress you! It's all part of the teaching/learning process, and whatever my limitations as a painter, I feel I really do understand the minds of my students.

I'm afraid I'm not really into many of the more sophisticated techniques using such devices as salt, scrapers, plastic wrap and candles, which seem often to be an important part of many modern watercolour exhibition works. I may be a bit old fashioned, but I do feel many students eagerly try out the latest trick, hoping, perhaps, that they might produce a masterpiece by accident, rather than concentrating on improving their skills with their brushes and paints. Still, I suppose my use of the hake is a bit revolutionary to the traditionalists, so I shouldn't be too dogmatic.

This is usually the chapter in most painting books where one is urged to paint such things as graduated washes on squares, but this book isn't like that. My techniques are all based on my three brushes, and probably 80 per cent of all the work is done with the hake. So I want to try first to show you how to

OPPOSITE
*I usually indicate foliage with the corner of the hake, holding it bent over and using little downward strokes. To get this effect don't use too much water! The branches are put in with the rigger afterwards, but only in the skyholes.*

18

RIGHT
*If the hairs tend to split into clumps,
dip the brush into water and gently
mould the hairs back into place with
the fingers.*

ABOVE
*An essential and continual procedure
with the hake – getting rid of the excess
water before mixing the paint on the
pallet.*

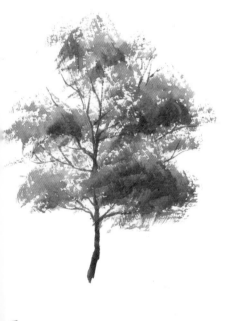

control it and use it to its fullest potential. As I've said, its mere size is meant to force you to simplify and eliminate unnecessary detail, but I admit it also feels clumsy and intimidating at first, and you've got to get over this by doing lots of little thumb-nail paintings with it in Burnt Umber. I don't mind if you try copying the little vignettes in the book; most of them are about actual size anyway.

What you have to realise is that the hake has a lot of surfaces and angles to it. The wet-into-wet skies are done lightly using the whole flat edge with plenty of water. I turn the brush on its corner to do distant trees, and for the nearer foliage I often use the heel of the brush lightly with richer and stronger paint. For a foreground trunk, I twist and turn the brush almost like a very large manuscript pen.

What I can't show you is the right amount of water to have in the brush for each technique. You'll only achieve this by trial and error after hours of working and practising. I can assure you, though, that you're invariably going to have too much water hiding in the brush. Nearly all of my students have this trouble at first, so a rag or sponge is absolutely essential to get rid of most of it before you mix your paint. If you've got a palette swimming with water, you can be pretty sure your painting will be out of control and look anaemic. I don't normally dip the whole of my brush in the water once I've started a picture, I merely dip in the top ⅛in so that I don't flood it.

You'll grumble a lot, too, and swear that your own particular brush has been badly made, and that the hair splits into various clumps. When this happens—and it will—pop the brush back into the water, and very gently mould it back with the fingers, while getting rid of the water at the same time. Don't expect it to spring back into shape like a sable. When it's half dry, it can be bent over and will stay that way, looking scruffy, but it's superb in that state for indicating foliage. I find each individual brush has its own character, rather like a horse, to be coaxed and cajoled, and sometimes, I admit, sworn at.

I use the hake itself in so many different ways. There is the full clear stroke right across the paper for skies, water or foregrounds. Another exciting effect can be obtained by holding it

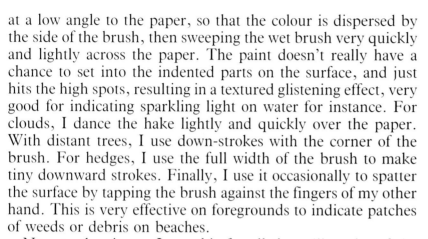

at a low angle to the paper, so that the colour is dispersed by the side of the brush, then sweeping the wet brush very quickly and lightly across the paper. The paint doesn't really have a chance to set into the indented parts on the surface, and just hits the high spots, resulting in a textured glistening effect, very good for indicating sparkling light on water for instance. For clouds, I dance the hake lightly and quickly over the paper. With distant trees, I use down-strokes with the corner of the brush. For hedges, I use the full width of the brush to make tiny downward strokes. Finally, I use it occasionally to spatter the surface by tapping the brush against the fingers of my other hand. This is very effective on foregrounds to indicate patches of weeds or debris on beaches.

Now to the rigger. I use this for all the calligraphy of the painting, for gradually tapering branches, for defining foreground grasses and all my figure work. For most of my country landscapes, I just use these two contrasting brushes.

The 1in flat brush with its absolute knife edge can be used with great economy, to indicate such delicate things as masts, by just touching the edge of the brush once, against the paper. By using tiny downwards strokes it will indicate walls, roofs and boats etc, and by tipping it on its corner it will indicate tiny windows and doors.

Now let's get down to the problems of actually getting the paint on to the paper. We don't really need to talk too much about putting paint on dry paper, as even beginners don't find this too difficult, nor do they have much trouble with 'dry brush', which is dragging an almost dry brush lightly and quickly over dry paper. This is very easy and safe, and sometimes useful for foreground texture. In both these techniques, the paint goes on and stays there.

The real control problems occur with 'wet-into-wet' as it's called. It is easily the most exciting technique, and to me it is the most beautiful; really the essence of watercolour. However, as I've often said before, the very phrase 'wet-into-wet' confuses people. If you do put wet paint on already wet paper you, at best, lose the shapes you intend and they diffuse into ghosts or, at worst, you produce back-runs or 'cauliflowers'. The simple secret is to *compensate* for the water already on the paper by using little, if any, on the second lot of paint. I always put my first coat on fairly wet. Then I take most of the moisture out of the hake by touching it on a rag; next, I mix some rich paint almost like cream, and put it on the original wet wash. As a result the shape painted on will certainly diffuse, and the

RIGHT
*This is a simple quayside scene showing the various uses of the three main brushes. Basically the sky and foreground are painted with the hake, the buildings and masts with the 1in flat, and the figures with the rigger.*

BELOW
*Wet-into-wet. This effect is obtained by putting layers of progressively stronger and richer paint on a damp wash.*

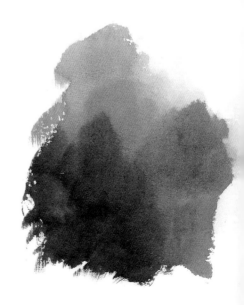

edges will soften, but not enough to lose the intended shape. You can probably understand it better by looking at some of the results on page 23. Once you have accepted this fact, you're on your way. But it sometimes takes a whole weekend to convince many of my students of this.

You're perhaps nearer to real wet-into-wet when painting skies. Here you can afford to use a little more water when putting on your second dark coat. With clouds, you're not too worried about retaining a pre-determined shape, and you can let the pigment expand almost uncontrollably in all directions. It's very exciting, and you have a good chance of creating a beautiful accident which you could never equal if you'd planned it.

The most dangerous stage in a watercolour is when the paper is half dry. You can do anything with it when it's really wet, as you can when the paper is dry. It is at this half-way stage that 'cauliflowers appear'. These are caused by putting paint on which has more water in it than is already on the paper at that particular moment, and of course it's at this fatal semi-dry stage where most of us can't resist the 'fiddling', which so often produces that dreadful mud. So beware!

If you really want to strengthen a wet-into-wet area, don't play about with it when it's half dry; let it dry completely. Then wet it with clear water, and you can work on it again without trouble. This, of course, applies if you finish up with a weak, disappointing sky—let it dry, wet it lightly, and start again.

Another technique we need to learn is graduation. This is

one of the best ways of avoiding boring areas, particularly large ones, in your painting. It's a way of gradually changing from light to dark value, or from warm to cool colour. I use it as often as I can for everything from woods to sides of buildings. A clear sky, for instance, should never be flat or uninteresting, but should be fairly rich blue at the top and then, gradually, become weaker and creamier as it reaches the horizon. This actually happens in real life — try making a tunnel with your hand and look through it at the sky above your head and then immediately again through it, just above the distant horizon.

The hake is very effective in doing this. After wetting the sky area with a weak wash just tinted with Raw Sienna I put a strong stroke of Ultramarine across the top and as I come down backwards and forwards I make the pressure lighter and lighter, until the brush comes off the paper entirely and only the original wash of Raw Sienna shows at the bottom.

To get the effect of distance in a flat field or an area of water that recedes from the front to the back of a picture, again the answer is graduation. A field can be created by using warm, rich colour in the foreground and cooler colour in the distance, and also by making the nearer area darker, getting weaker as it recedes. With a lake, I'd again use the darker colour in the front, gradually weakening it. My own method of doing this is to put a flat wash all over the water area, wait for it to dry then turn the painting upside down, put a dark wash over the foreground water, and graduate it to almost nothing on the horizon. Once the whole thing is dry, turn it right way up and the effect is quite surprising.

Never neglect the use of graduation in foregrounds, either from the front to the back, or side to side. It can often solve the problem of what to do with your foreground; add a few streaks of grass and maybe a little splatter and it's all finished.

We've talked about the techniques of putting paint on, now let's talk about ways of getting the paint off the paper, or preserving white areas in your paintings. The usual solution seems to be to reach for the masking fluid, or use white paint afterwards, both of which I try to avoid if I possibly can. Masking fluid I do sometimes use, but only in about one in a hundred paintings, if I need a really intricate shape like a windmill sail against a dark sky. I just find it a bit of a nuisance, and it seems to ruin so many of my brushes (through neglect I must add). It seems awkward stuff to use in the open air, but, I do keep some in the studio. The idea, of course, is to put yellow latex rubber on all the areas you want to preserve in white, before

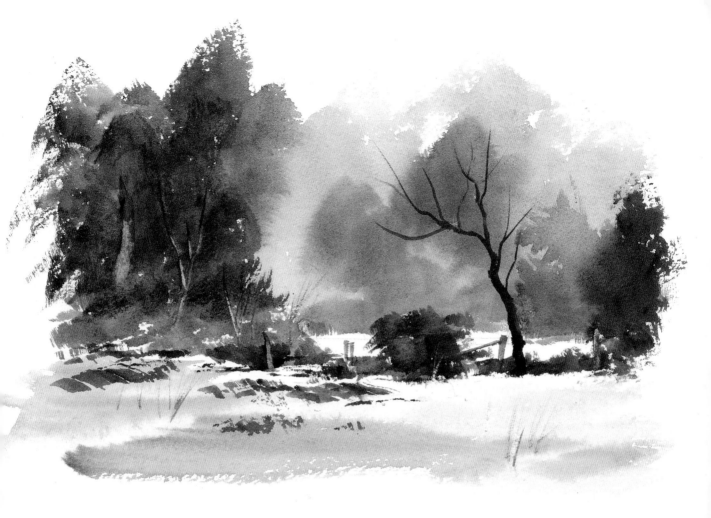

*The light trunk and posts were scraped out whilst the paint was still damp, and the thin branches added with a flick of my fingernail – don't do this too soon or they'll fill in.*

*The distant woods are in different strengths of paint, the darker stronger paint having been added with the corner of the hake whilst the first coat was still wet.*

*The dead tree was added with the rigger, after the background was dry, as were the grasses.*

*The foreground was done with a very quick sweep of the wet hake; beware! don't be tempted to overwork the foreground.*

you commence your watercolour, then rub it off with your finger when you've finished. Some artists, notably John Blockley, use it very successfully as an essential part of their overall technique, utilising it in practically every painting. Try it out for yourself and then decide. White paint, put on afterwards, is also alien to me. I feel it sticks out like a sore thumb in an otherwise transparent painting, although a lot of famous artists, from Turner to Rowland Hilder, have used it.

The best way, I believe, is to plan your painting beforehand, with your tonal value sketch, decide just where you want to leave your white areas, and then paint round them. That sounds a bit glib, but it doesn't have to be half as precise as one often thinks.

If I was doing, for instance, a mountain behind a Greek village, I'd paint most of the mountain with the hake, and then switch over to the 1in flat to put in a sharp stepped edge at the bottom; with a few roofs and one or two verticals and some windows I'd have a village. If, say, I wanted a white bridge,

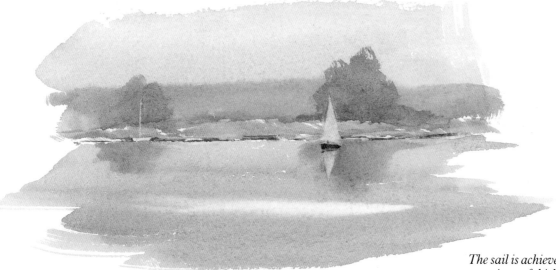

I'd paint my background up to the top, leaving a nice, hard, curved edge and fill in under the arch. Putting white boats on sea is another problem. Again, you don't have to be precise, providing you leave one or two semi-accidental gaps. These can easily be turned into boats with a touch of dark with the 1in flat brush, or perhaps a vertical mast.

I always like to leave some virgin white paper in a painting to give it sparkle, but it must be relevant to the subject matter, and not just at random all over the picture, when it can look very irritating.

I often use my little fingernail to flick in light grasses against a dark area or a few light trunks in a mid-distant wood. Occasionally, I may even use the other end of my hake to do the odd light tree trunk. You have to be very discreet and economical with this trick. It can look dreadful when overdone. Wait until the paint is half dry; if it's done with the paint too wet, the marks will fill in and become dark.

I find a small hog's-hair oil-painting brush very useful sometimes, to take off paint to lighten an area. Its bristles are abrasive enough to do the job without destroying the paper surface, but do it gently, and don't be in too much of a hurry.

By using two pieces of paper as a mask with a tiny gap in between, you can make white masts. By overlapping them at an angle, you can make distant sails. Again, you can use the hog's-hair brush with clear water, although I often use a clean rag over my index finger, and spit!

To get the white streaks on water caused by wind ruffling the surface, wait until the river surface is semi-damp, and then take them out with the edge of a dry hake, slowly and deliberately on one stroke. These streaks are always more effective crossing a dark reflection, but restrict yourself to one or two at most—one near and one far. I also keep a Stanley knife blade to be used very discreetly for, say, a distant mast. This time, wait until the paint is completely dry and use it very gently, to avoid destroying the paper's surface.

To summarise the whole chapter it might help if I go through my own very basic procedures when I'm painting a picture. I first look at the scene in front of me, whether it's in the open or from a tonal sketch in the studio, and try, mentally, to divide

*The sail is achieved by crossing over two pieces of thick paper and wiping between with a clean damp rag.*

*The streak is added by wiping out with the edge of a 'thirsty' hake whilst the river is still damp.*

*The mast is made by gently scratching out with the point of a Stanley knife blade – but very gently!*

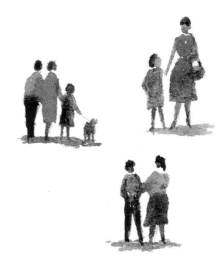

*These little figures were done with the rigger. Don't make them too stumpy, and keep their heads small.*

*Practise plenty of trees like the one below, using the rigger.*

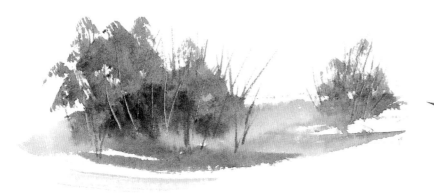

ABOVE
*This simple foreground feature was produced with the corner of the hake, the rigger and a fingernail.*

the picture up into three or four planes. When I actually start painting, I work from the back to the front of the picture, always doing as much of it as I possibly can with the hake, keeping it fairly weak, flat, and perhaps soft at the back, then very gradually increasing the strength of the paint, plane by plane, until I eventually reach the foreground. I only turn to the 1in flat brush if I want sharp edges, and normally, in a woodland scene or landscaped without any buildings, I wouldn't use it at all.

The sky, being the furthest away, I always do first, as this sets the mood for the whole painting. I then immediately paint in my background. If it's, say, a sharp-edged hillside, I'd wait for the sky to dry, but normally, I like to paint my distant trees in while the sky is still damp, using the corner of the hake with a fairly strong paint to compensate for the dampness in the sky, otherwise it would all run up and disappear in a sort of foggy haze.

The only time I wet the whole of my paper completely before starting, is if I'm painting, say, a woodland scene in depth. Then, with the paper wet, I drop in all my distant cool greens. Then as I gradually work forwards towards the front, progressively using richer and stronger greens, the paper, of course, is drying, so by the time I reach the foreground I can put in sharp edged branches and foliage, all of which give a feeling of depth to the scene.

In this chapter I've shown you a fair selection of my techniques, but don't be surprised if you come across a few more later on in the book.

BELOW
*This simple beach scene demonstrates the use of the 1in flat brush, which I used throughout.*

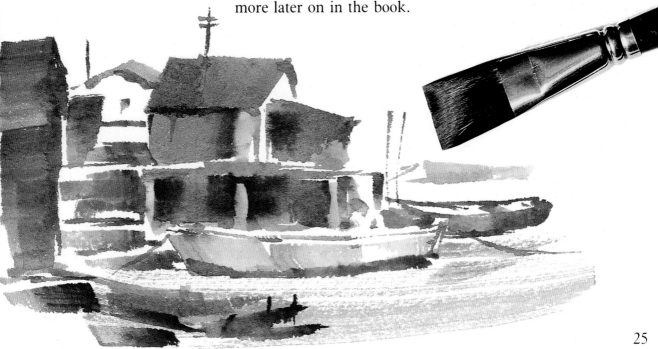

25

# Tonal values - the key to it all

On my courses, the first morning is a bit depressing for all of us (I hasten to add, it doesn't last too long, and I do warn the students beforehand). On the evening the students arrive, I give a demonstration, and they all get very excited. 'I can't wait to get started', are the words I hear over and over again.

The trouble begins when I tell them that they're only going to be allowed one colour, Burnt Umber, for the first few hours. A bit disgruntled, they start. I make them concentrate on small value sketches, lots of them, preferably on cheap cartridge paper if they've got it, so that they don't feel they're wasting 'good' paper on exercises.

I find the first half hour really revealing. Even students who regard themselves as relatively experienced have quite a lot of difficulty capturing a full range of values. Away from the cushioning effect of the various colours, they have to produce them entirely by carefully varying the water content. If the total value range from purest white to darkest black were to be likened to a numbered scale with white as 1 and black as 100, the beginners all seem to hover around the 40 – 60 mark, giving a very flat, anaemic look with no sparkle or contrast. Most of my students have read my previous two books, and probably lots of other painting books too, but have carefully tip-toed round these tonal value chapters to get to the more interesting sections. However,

BELOW
*This tonal sketch in Burnt Umber helps to simplify the various tones in the picture.*

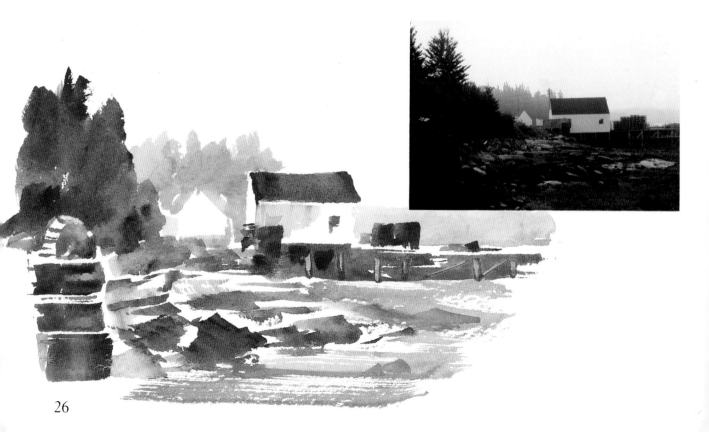

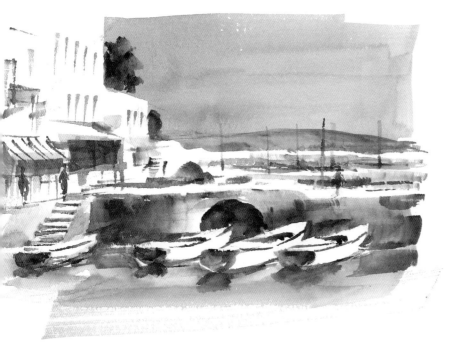

*This complex harbour scene in Greece needed to be drastically resolved and simplified in tone before a final painting was attempted.*

BELOW
*I've tried below to show you here how the tonal values relate to the various colours.*

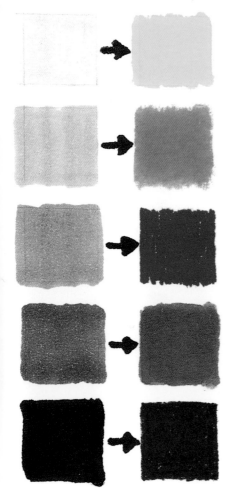

having got you this far, I hope to keep you this time!

The exercise with Burnt Umber is to make the students really understand tonal values. What makes many of them confused, is that they think value only applies to greys. Value is the lightness or darkness of any colour. If applied to blue, it would range from the palest blue on a horizon, to the midnight blue of a man's suit. If it were red, it would range from the merest hint of pink in a dawn to a rich dark magenta. In yellow, of course, the range is much smaller. It would only go from a pale cream colour to the rich yellow of a sunflower; you can't make yellow go any darker.

Try taking a scene, and reducing it to a colourless pattern of light and dark masses, leaving out all the details. Just concentrate on finding out whether each element is darker or lighter than the element next to it. Never mind what the various colours are. You'll find it much easier to do this if you look with almost closed eyes at a scene to eliminate the details, the masses of the differing values will then become more apparent. Remember, this has absolutely nothing to do with what shade of green or purple those distant mountains may be. This counterchange, as it's called, is my own personal hobby-horse. I've talked about it a lot in my previous two books, and I make no apologies for bringing it up again, because although many of my students know all about it in theory (I'm always nagging them about it), when it comes to actually using it effectively on their own pictures, they're too busy concentrating on other difficulties. As a result their work often looks bland and flat.

For new readers, let me explain. Counterchange is a constant and deliberate painting of dark shapes against light and light shapes against dark throughout a picture, to clarify it, thus making the picture more 'readable' to the viewer. It's part of an artist's job not only to look for these contrasts in tone between

adjacent objects, but to actually exaggerate or intensify them throughout the picture. This applies particularly if you're working from photographs, most of which have many areas which run into each other tonally and look vague and unsatisfactory.

There's nothing new in this technique; it's been used by the great Masters throughout the ages. If it's done properly, the viewer isn't really conscious of it, and when looking at the picture, it just appears as a thoroughly satisfactory result. It's only really apparent when the principle hasn't been applied by the artist, and the picture appears flat and anaemic.

One of the best ways of really understanding the technique is to study closely the work of such artists as Rowland Hilder, a man whose work I admire tremendously. There are many collections of his paintings in book form, but when I say study, I really mean go through each picture, analysing the way in which he dramatises and contrasts each object against its neighbour. Another great exponent is Edward Seago, whose work has influenced me more than any other artist. So much so, that I've produced a volume containing ninety of his paintings with a running commentary on his methods of achieving drama and simplicity.

The principle of counterchange is taken to its ultimate degree by what is known as the 'California School' in America. Perhaps the most famous exponent of this technique there is Frank Webb, whose work I find very exciting. Before he even sets a brush to a final painting, he spends hours preparing his pattern design until he's completely satisfied, with the result that his work is full of contrast, clarity and readability, as are Rowland Hilder's paintings but in a completely different way.

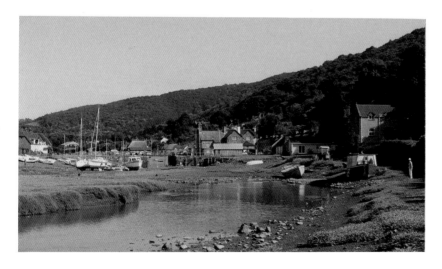
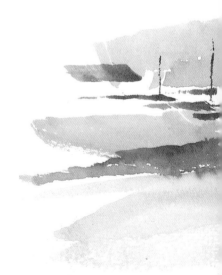

So many students, when I take them down to the river to sketch, seem to have little idea how to go about it. They almost always work too large, and they're much more interested in drawing contour lines round things and then adding what they call 'shading', rather scruffy lines of about 45° all about the same tone. When they get back to the studio to paint, they haven't provided themselves with enough information. They may have got the rough shape of the hillside, but not whether it is darker or lighter than the tree in front of it; and, of course, everything is drawn exactly as it was, with never a thought of improving the picture's design.

You may say, you now understand value sketching, but what's the purpose of it all? The fact is that once you have learnt to observe value as well as you can observe colour, you've taken a giant step to becoming a real painter. When you've discovered how to separate and recognise the values, the next task is to plan these value ranges into strong, easily identified value patterns, which can be seen instantly. Shepherd and marshall all these various elements in front of you into three basic light, medium and dark shapes. This needs a lot of practice, but is enormously rewarding once you've learnt the skill and will vastly improve your finished work. Always make the mid-value shape the biggest one, and make the light and dark shapes

BELOW
*The watercolour sketch shows how a relatively complex scene can be resolved into a few simple washes, making good use of the white paper itself. Notice how the house on the right has been counterchanged against the hillside behind.*

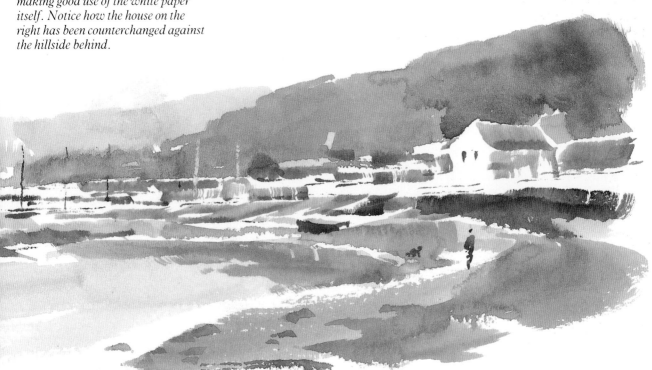

smaller, but never equally sized. One or the other should dominate. These light and dark shapes should also touch or overlap each other if possible.

In my classes, I give my students two or three photographs each, and then get them to simplify and dramatise these into small value patterns perhaps two or three inches wide. Do lots of them, working loosely and boldly, with plenty of paint (or this might be a good time to try my spirit-marker kit—see page 17). Most beginners tend to be a bit timid and work too pale. You'll know when you've produced a good one, because when you squint at it through half-closed eyes it will look like the real scene.

Look at some of the examples I've done here. I've found, within an hour or so, that my students are producing these quite well. The trouble comes when I tell them to start using colours; they usually find it difficult to relate colour to the values. The following illustrations will give you some idea of the transition.

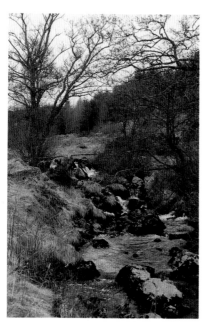

*Another exercise in simplification, with a rather fussy scene being indicated by relatively few strokes of the hake and rigger.*

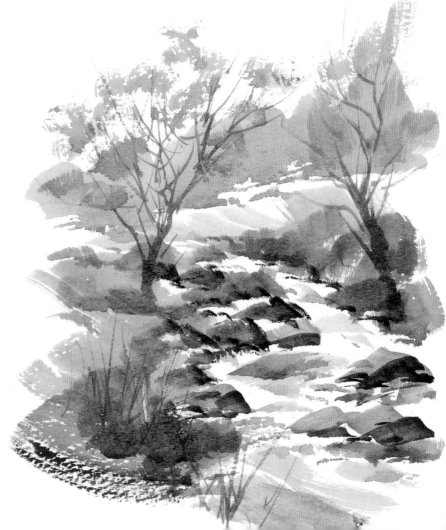

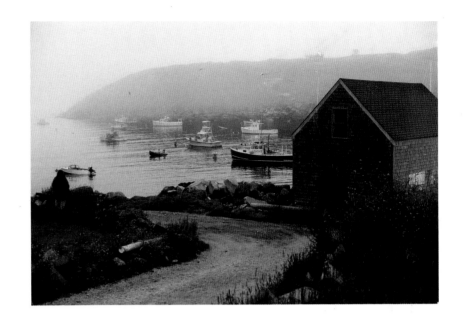

On this page I'm showing you the use of the three tonal markers shown on page 16. These quick rough sketches, which take only seconds to do, can show you alternative patterns of light and shade, and you may find them easier to produce than the Burnt Umber drawings.

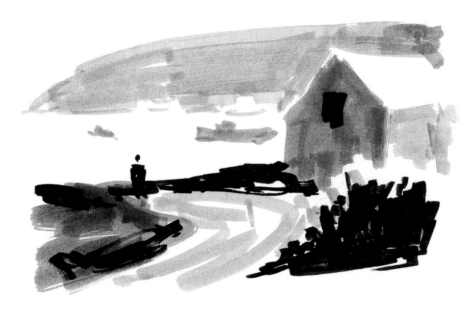

You can see here how the tones have been resolved in two different ways, the one on the right making use of a strong shadow from the hut as part of the design.

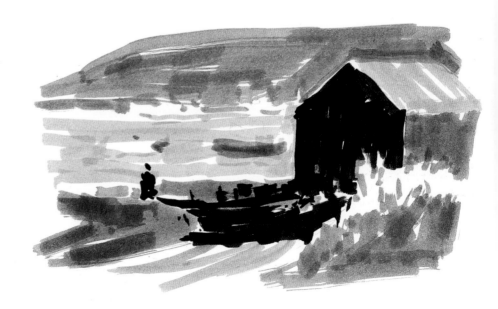

# Designing your picture

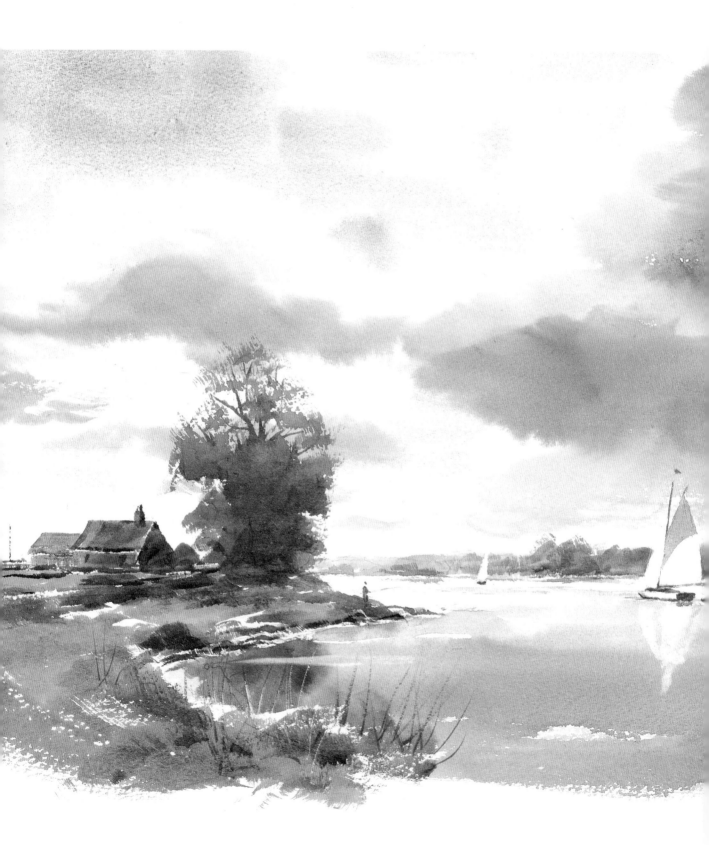

*This is a painting on the Norfolk Broads where I've spent many a happy sailing holiday. Note how the eye is taken along the bank to the promontory which points to the main object of interest – the yacht counterchanged against the trees behind it. The dark clouds also counterbalance the house and trees.*

The last thing I want to do in this book is to entice you into changing your painting style. How much detail you want to put into your finished work is entirely your choice. Excellent paintings can be done very realistically, or taken to almost complete abstraction. What seems to divide the excellent and lasting from the thousands of mundane and forgettable works is the underlying design control. Nothing really separates the amateur painter from the professional more than this basic abstract organisation of elements.

So now I want to introduce a stage into your painting that many of you have never attempted, don't want to attempt, don't think is necessary, and may consider a waste of paper anyway! You probably can't imagine how it will make much difference to your painting. Believe me, it will. As I've said before in previous books, most students seem to have a perfectly good sense of design, until they try to paint specific subjects. They know all about balance, unity and harmony, or think they do, but when they sit down in front of a scene, or even work from a photograph, then the problems of drawing and painting become so important that organising the tonal composition is forgotten. A good painting is more than a group of well painted sections. You may have painted the sky freshly and beautifully, and the hills and trees are well drawn and painted, yet you get the uncomfortable feeling that somehow the whole thing doesn't hang together, that it lacks unity.

I'm actually writing this chapter on my balcony, in siesta time, on the Greek Island of Spetzes. All morning, I've been with my students trying to get them to do value pattern sketches, before they start their paintings. Whilst most of them are still unconvinced that they need to do them, some have attempted them out of a sense of duty, and made a bit of mess of them because these tiny sketches need a discipline of their own which has to be learnt. Most of them make them too large and over fussy, with too many details, and don't simplify their tones.

The problem with watercolour students is that they mostly paint for pleasure. They don't have to pass exams, so they've got no real compulsion to do the difficult bits. This business of designing a painting first takes a lot of concentration and brain work, which many may not be willing to give. In my class of eighteen on the Greek Islands with me at the moment, four are taking to this value sketch idea like ducks to water, and it's really beginning to show. Others are fighting it like mad. They're on holiday aren't they? They just want to paint away happily, chatting to their companions. The other stuff is

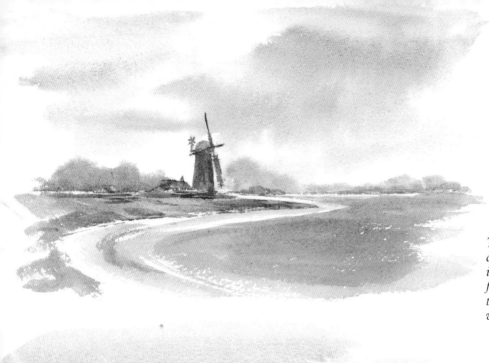

*These are a couple of well-tried ways of directing the eye to the main object of interest. Here the winding path finishes up at the windmill – but not too directly: it gives you a chance to wander around the picture first.*

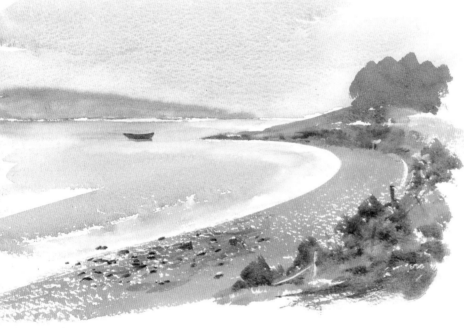

*Here the eye enters at the bottom left of the picture and is carried around the curved shoreline to the boat which, though quite tiny, is an important part of the design.*

too much like hard work. They glance around to make sure I'm not about, and get on with their 'proper' paintings, which they can take home to show their friends. Others do a reasonable job of their pattern sketch, simplifying their tones. So far so good, but then they put it away and start their painting without a second glance at the sketch. The result is, of course, that at the evening crit. the finished painting is much less satisfactory than their first sketch. However, I must explain that this is only the second day. I hope through my good-humoured nagging, the penny will finally drop by the second week, and some lovely paintings will start to emerge.

What is really involved in designing a watercolour, as opposed to just letting it happen? First, accept the fact that nature almost never provides you with a ready-made composition which can't be improved upon. A really good painting is usually a skilled re-organisation of what you actually see in front of you, whether it be from an actual scene or a well-composed photograph of it. You see, the trouble is, that nature and art are not the same

In the tonal sketch of this Brunei beach scene I've reduced the tone of the distant trees, counterchanged the two beached boats in different ways and used a distant boat to help balance the painting up. I've also cleaned up its foreground a bit.

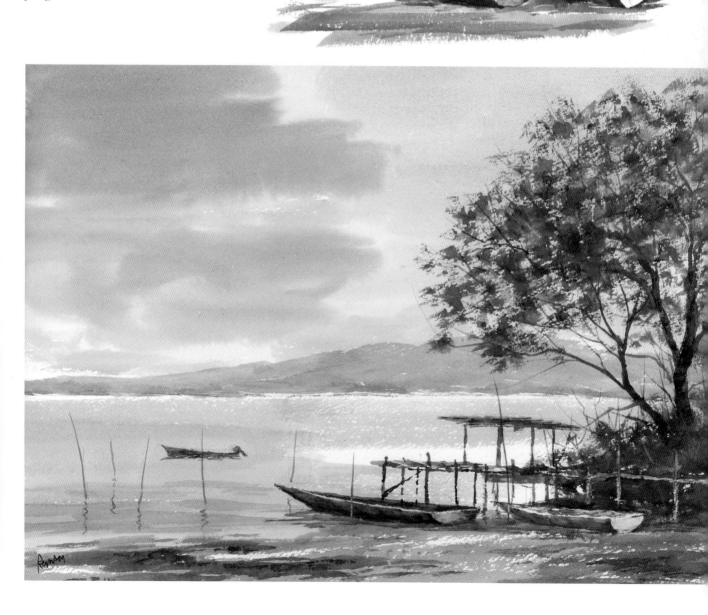

thing at all. A glance at any photograph, no matter how well taken, will show you that nature is not in the picture-making business. A relationship between the large areas of various tones is never really right, why should it be? It's your job as an artist to re-create it using man-made order, in other words, to design.

One sees so many boring paintings which are unsuccessful because the artist had not thought out what he or she wanted to say in the first place. Without a clear objective, you haven't much of a chance of achieving anything worthwhile. What do I mean by objective? It might be that you want to convey the colour and activity of a Greek harbour scene, or the brooding, cloudy, atmosphere of a Scottish loch with approaching rain. Or maybe you want to convey a strong abstract pattern made by a white sailing boat crossing in front of a dark quay. Whatever it is, it's vitally important that, before you even put pencil to paper, you ask yourself clinically what was it about this scene that turned you on in the first place; what the picture is all about.

This should lead you to your next decision—where to put your centre of interest, the focal point of the whole painting. This should attract the eye immediately, and there must be just *one*. Be stonily resolved to let nothing distract you into introducing another equal competitor into the same painting. Everything else must be subservient to it. Having got this idea firmly into your head, the next question is, where should it go on the paper, and how do you make sure everyone looks there first before exploring in in the rest of the picture? The rules of positioning it are straightforward and commonsense. Never, never in the centre of the paper, or right on the edges. The ideal and most interesting place for it is where the distance from it to all four edges is different, which avoids boredom.

Having decided where the focal point is to be, there are several ways of attracting maximum attention to it. You could make sure that it is the area of maximum value contrast—the darkest dark in the picture against the lightest light always does it. Another way is to put much more detail in at this point than in the rest of the painting. In fact, the further away from the centre of interest, the less detail you need. You could also make it the brightest spot of colour in the whole picture, with everything else portrayed in a duller, greyer colour.

Apart from using tone, colour and detail to attract attention, there are other devices to make sure you lead the unsuspecting viewer to it, such as the converging lines of a road, or trees, or the curve of a beach, or a zig-zag path. The longer it takes to get there, the more time you have to appreciate the rest of the

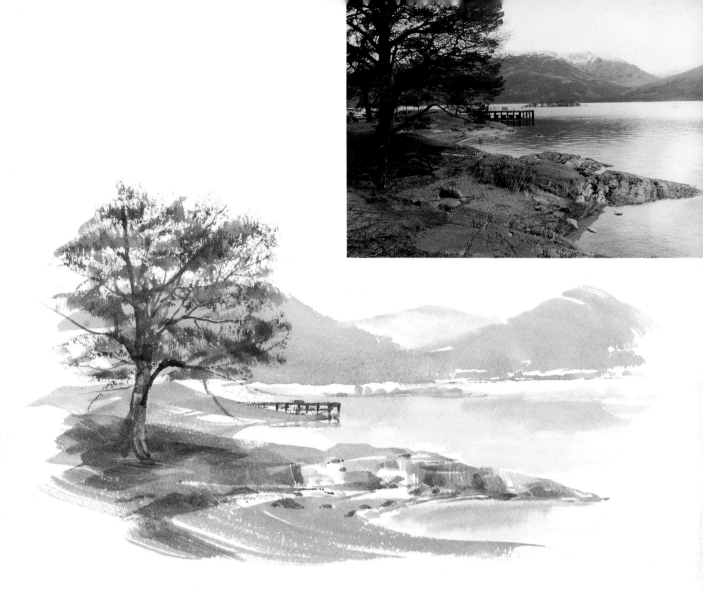

*Not much needed to be done in this view on Loch Lomond. The scene itself was fairly well balanced. All I really did was to try and improve the foreground beach by giving it a more satisfactory curve.*

picture. Mind you, having used one or more of these devices to lure your viewer to this particular spot, you must make sure that you've got something of interest to show them when they get there. It is, as it were, the star singer, the other things in the picture are the backing group. The making of one centre of interest is one of the many rules of design. There are others which should be understood and obeyed; most of them are just commonsense and are not difficult to learn, and I'll try to put them over as simply as possible.

Making sure your picture is balanced properly is another rule which is so boringly obvious until you sit down in front of your scene. You've probably read dozens of books with diagrams of see-saws with a big weight nearer the centre being balanced by a little weight on the other end. In the long run though, it's up to your own good judgement and intuition—just make sure you don't forget it!

Another factor which you should build into your design is to increase the illusion of depth in your painting. A large proportion of students' work is too flat. They just haven't applied the rules needed to create this; a third dimension on a two-dimensional piece of paper.

The artist has quite an armoury of devices to use, but not necessarily all at once in the same painting. The most obvious

one is perspective, making lines converge, and shapes become progressively smaller as they recede into the distance. You may say that's only copying nature anyway, but there are lots of ways to emphasise and manipulate the existing facts to make the design more dramatic. One device I'm particularly fond of myself, is to use soft wet-into-wet in the distance, with sharp rough texture in the foreground. For instance, if I wanted to show a line of trees or a wood on the horizon, I'd drop them in before my sky had dried completely, to give a softness to their tops, whereas, as I came towards the foreground, my edges would become sharper, with more dry brush, and generally more detail. This combines with another basic rule, that things are generally darker in the foreground, becoming lighter as they recede into the distance. You see it emphasised in misty weather, but it is a device which can be, and is, used to give the illusion of depth. It is called aerial perspective, and is basically a blue haze in the atmosphere, like a series of veils gradually cutting down detail, flattening shapes and generally giving a blue bias to distant colours.

I must admit, I shamelessly exploit and exaggerate this phenomenon to my own use. It is especially useful in getting depth into a woodland scene (more of this later—see page 83). Boats, cars, and of course, people, should face into the picture if possible, especially if they are anywhere near the edge of the paper. Your painting should appear complete in itself, so avoid putting interesting things too near the sides, otherwise it will look as if it's just a part of a bigger scene that runs off the edge of the paper without any change of intensity. Even subdue your colours as they get further away from your centre of interest.

Another thing I invariably do is to try and improve the curve of a path from the original or change the course of a river or stream slightly, if it produces a smoother, more satisfactory shape. This applies also to shore lines and beaches, which can be drawn with a quick swing of the arm, taking out all the kinks. It's surprising how this can give the whole picture more vitality and vigour. I find students so often laboriously copy every change of course and kink, because it's there, and they're surprised how much more satisfactory their paintings can look with a bit of linear purification.

After you've done your value sketch, look at it critically, and decide whether it obeys most of these rules. If it leaves you fairly satisfied, you can then start your finished painting with a certain amount of confidence, freeing you to concentrate on the actual handling of the paint. But do prop the sketch up in

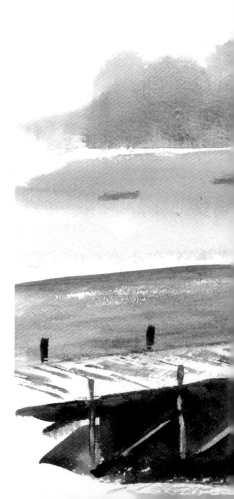

front of you as you work; it's very easy to stray from it unless you're constantly checking, and you'll end up disappointingly with a finished painting which lacks the power, punch and unity of the original value sketch.

I hope all these rules and regulations haven't scared you to death and put you off completely. Once you've learnt to observe them, however, you'll start to use them automatically, rather like using the highway code, to bring more order and professionalism into your painting.

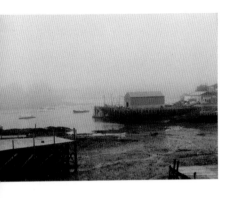

*In this Maine harbour scene I've used a similar device to the bottom picture on page 34, shaping the curved waterline to give movement and direct the eye through the picture.*

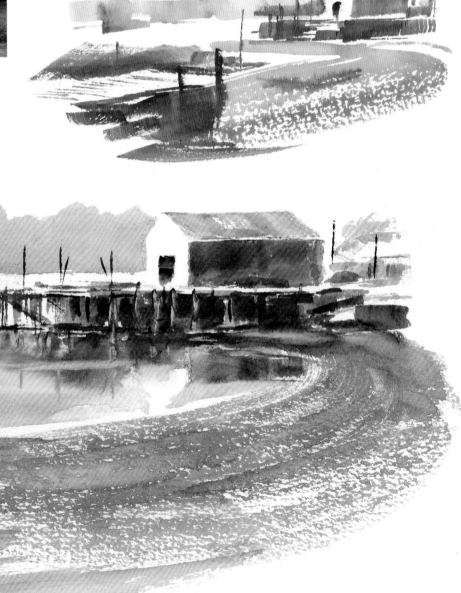

# Photography without shame

To artists, cameras are a sensitive subject. Some use them occasionally, but swear they never touch them. Some reluctantly admit to owning one, and others scream at the mere mention of a camera and make you feel guilty and ashamed if you even bring the subject up. Mind you, if you imagine that you are going to use a camera to save you having to think, or learn to draw properly, or use your imagination, I'd be inclined to agree with the screamers. If you use a camera as a crutch, to make all those uninitiated people around you believe you are a better artist than you are, surreptitiously copying photographs behind closed doors, then the camera is a thoroughly negative thing. It positively stifles creativity, and is a barrier to you maturing as an artist. There is nothing so boring as looking at a painting that has obviously been copied directly and mindlessly from a photograph. It is a sterile and lifeless piece of work and reveals nothing of the artist's own feelings and personality. But, and this is a big BUT, if you use a camera in a positive way, as a wonderful gatherer of images to supplement your sketch books, to produce a wealth of basic material which will, through your own sensitivity and creativity, produce subtle, powerful paintings, then I'm all for it.

Some of the advantages of the camera are that it is compact and light (I've nearly always got one in the car with me), and that you can gather a lot of material in a short space of time. It can record constantly changing light patterns, such as shadows of swiftly moving clouds on hillsides. It can capture rapid weather changes, and you can take photographs in atrocious conditions, such as pouring rain, and snowstorms, which, although making great material for watercolours, present impossible problems for on-site painting or even sketching.

It's vitally important that you regard a camera as a means to an end, not as an end in itself. You can take a photograph, for example, and use just a bit from the middle of it. You can change the season, or the time of day by making it a misty dawn rather than a sunset. You can even combine several photographs together to produce a completely different image; a sky from one, a river from another and even a foreground tree from a third—but make sure you don't put a yellow sky with a blue river! In other words, you should use the camera, just as a recording device, to stimulate your memory of a scene, weeks or even years afterwards.

I hope I've presented the arguments, both pro and con, as fairly as I can. If you're still with me, my next task is, firstly, to try and make you more skilled and sensitive with the camera,

*My equipment – starting with a small carry-all which contains my 35 mm camera with ordinary lens, together with the zoom lens and wide-angle lens. Always carry plenty of films, otherwise you'll inevitably run out just before you find your perfect subject!*

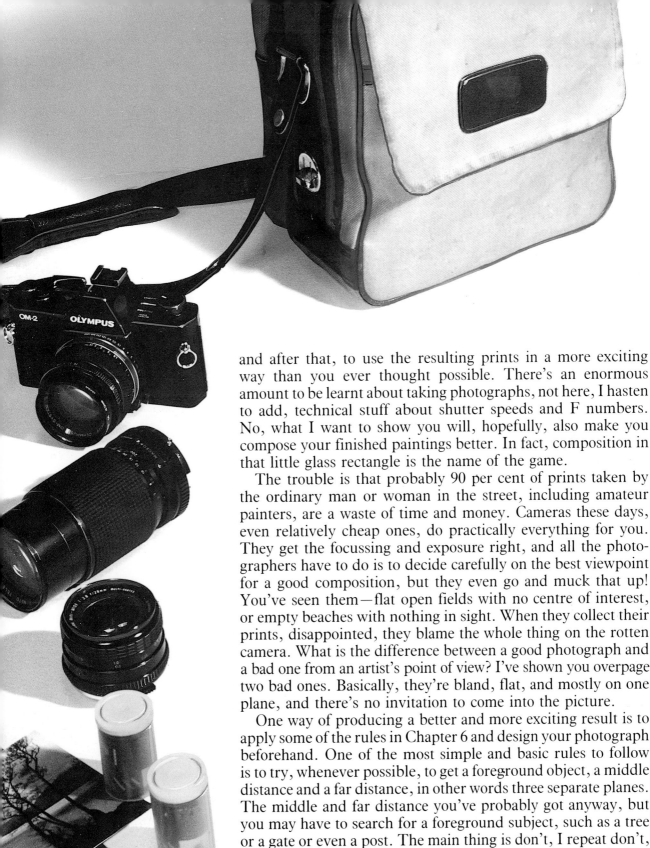

and after that, to use the resulting prints in a more exciting way than you ever thought possible. There's an enormous amount to be learnt about taking photographs, not here, I hasten to add, technical stuff about shutter speeds and F numbers. No, what I want to show you will, hopefully, also make you compose your finished paintings better. In fact, composition in that little glass rectangle is the name of the game.

The trouble is that probably 90 per cent of prints taken by the ordinary man or woman in the street, including amateur painters, are a waste of time and money. Cameras these days, even relatively cheap ones, do practically everything for you. They get the focussing and exposure right, and all the photographers have to do is to decide carefully on the best viewpoint for a good composition, but they even go and muck that up! You've seen them—flat open fields with no centre of interest, or empty beaches with nothing in sight. When they collect their prints, disappointed, they blame the whole thing on the rotten camera. What is the difference between a good photograph and a bad one from an artist's point of view? I've shown you overpage two bad ones. Basically, they're bland, flat, and mostly on one plane, and there's no invitation to come into the picture.

One way of producing a better and more exciting result is to apply some of the rules in Chapter 6 and design your photograph beforehand. One of the most simple and basic rules to follow is to try, whenever possible, to get a foreground object, a middle distance and a far distance, in other words three separate planes. The middle and far distance you've probably got anyway, but you may have to search for a foreground subject, such as a tree or a gate or even a post. The main thing is don't, I repeat don't, press the shutter the instant you see what you think looks like a nice view. The majority does that, and this is where you, as an artist, start to use your intelligence and good taste. Walk around looking through the viewfinder—don't you dare press that shutter yet! A lake and mountain behind it may look pretty, and everyone around you may be snapping happily. Discover, however, how much more interesting that same scene could be with a strong foreground tree on one side to give a vertical

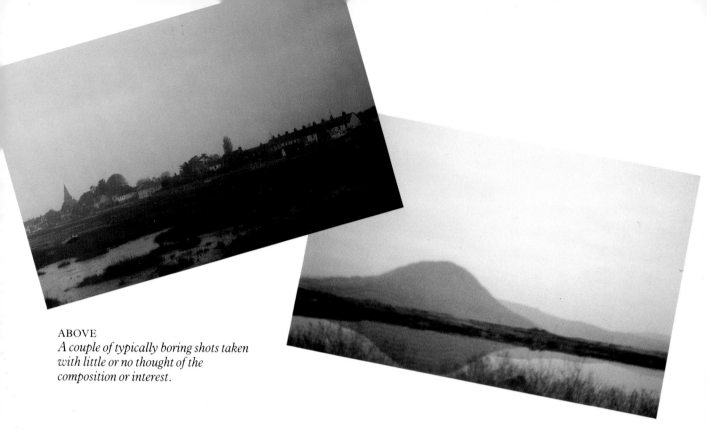

ABOVE
*A couple of typically boring shots taken with little or no thought of the composition or interest.*

feature and to contrast with the horizontals of a lake and hills. It will also give it depth.

Another rule mentioned in Chapter 6, is to find a lead into the scene, be it a curved path, a wall or even a curved sweep of a beach or lake edge. They are all invitations to come into your picture. Never put a wall into the front of your photograph; this will only keep your viewer out. This a fault I've seen hundreds of times in both photographs and paintings. Don't always try for distant landscapes, look for attractive close-up subjects where you can exploit contrasting textures, such as a busy brook with moving, sparkling water, moss-covered rocks and grasses or even the base of a tree with its rough bark surrounded by wild flowers. Look at everything from many different viewpoints before you actually take the photograph. Don't always take vast panoramas in bright sunshine; some of my best photographs have been things like a single boat in a fog. The students on a course with me often think that I'm mad when I go out with a camera at 7.00 am in a thick fog or the pouring rain, until they see the results. I'm not technically minded, and I'm not too bothered about how the camera works out the right apertures and shutter speeds for me. I want to concentrate all my attention on that vital viewfinder.

You can, of course, buy fast and slow films—the technical term is ASA. If I'm taking pictures in the summer or on the Greek Islands or in Australia, I use a film called ASA 100 and set my camera accordingly. However, if I'm taking photographs in the winter or in poor light, I choose a faster, more sensitive film like ASA 400, which gives me much more latitude and can cope with subtler contrasts.

Let me just go over my equipment. I've got a single lens reflex camera known as an SLR. They are, these days, almost invariably Japanese, and they do most of the brain work for

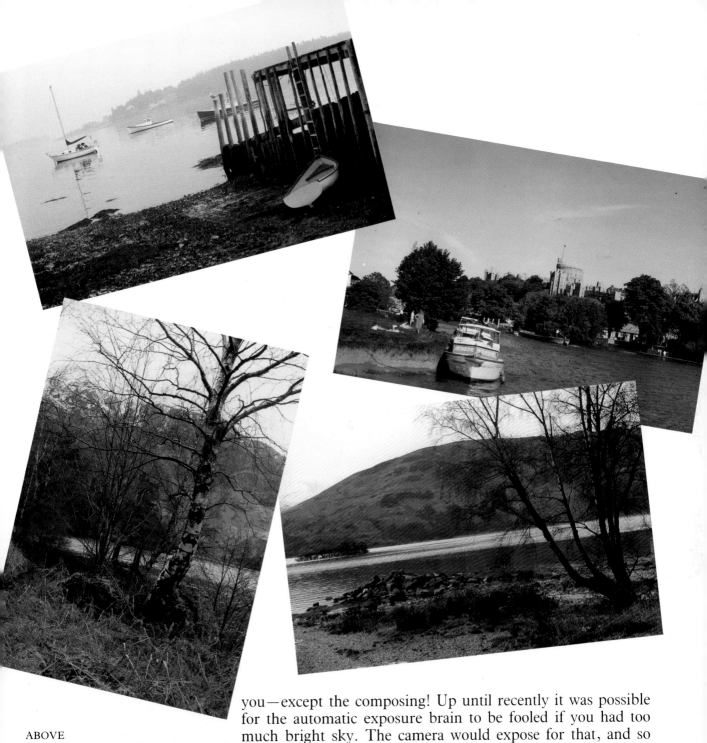

ABOVE
*Here are four shots with a little more imagination and balance. In each case I looked through the viewfinder many times and moved around quite a lot before I was satisfied with the composition and finally pressed the shutter. However, there's still a lot of work to be done before they'll make good paintings.*

you—except the composing! Up until recently it was possible for the automatic exposure brain to be fooled if you had too much bright sky. The camera would expose for that, and so the rest of the picture would be too dark. However, now these clever Japanese have solved that one too. My latest camera has got a thing called a spot programme. A tiny area in the centre of the viewfinder now controls the overall exposure, even if it's pointed at a dark tree against a bright blue sky.

My other two pieces of equipment are a wide-angled lens and a zoom lens, which are interchangeable in seconds with my standard lens. I probably use the standard for about 80 per cent of the time. However, if I'm close to a subject and can't get it all in, I switch to my wide-angled lens, which is in effect a reducing glass, and therefore gets more in. The zoom lens, on the other hand, is rather like a small telescope, and will bring far-off objects nearer. They both have their uses when you want to compose a picture.

Having said all this, you don't really need an expensive camera costing a fortune, any more than you need large sable brushes or hand-made paper to produce a good painting—it's the knowledge behind it that counts. In fact, I've seen dreadful photographs taken with an apparently fool-proof camera costing hundreds of pounds.

So, having got your, hopefully, much improved photographs back from the developers, lay them out, and look at them. In spite of the extra care you've taken in composition, and all my good advice, a few of them will be duds—a lot of mine are! The best of them, however, will excite you and make you immediately want to get out your paints and work from them. But hold on, this is the dangerous time! Let's look at one print coolly, critically and analytically. Almost inevitably, the values will be wrong, especially in the distance, where they'll probably look too dark. All these depths will need to be resolved and revised. There'll also, probably, be far too much in the picture, with various things vying for attention. Many of these distractions will have to be ruthlessly discarded.

Start by what's called 'editing' the print, using two L-shaped pieces of paper, overlapping them and pushing them around on the photograph, until you've cut out all the boring bits and homed in on the real heart of the scene. This process alone is fascinating, and can teach you a lot about picture making. You can spend many a winter evening doing this. You may find, that through this process, many of your 'failures' can be made to look quite exciting. A print taken as a horizontal shot may be cropped as a vertical and vice versa. Don't accept the first cropping of your print; for instance, try it with less foreground and more sky, or try moving that white cottage on the left of the picture over to the right. The possibilities here are endless, and you're learning all the time.

Now we come to the next and very important stage, that of resolving your chosen picture into a strong and simple value pattern, to produce a co-ordinated distillation of the scene. This tonal value pattern should be instantly readable, and the darks, lights and mid values should be easily seen even from across the room. You can do this for hours, turning out hundreds of them in soft pencil, or as I like to do, tiny watercolours in Burnt Umber. They need be no more than three or four inches wide. This process will teach you much more than constantly attempting 'concert performances' for Art Society exhibitions.

So you see, to artists, photography need not be a 'dirty' word after all!

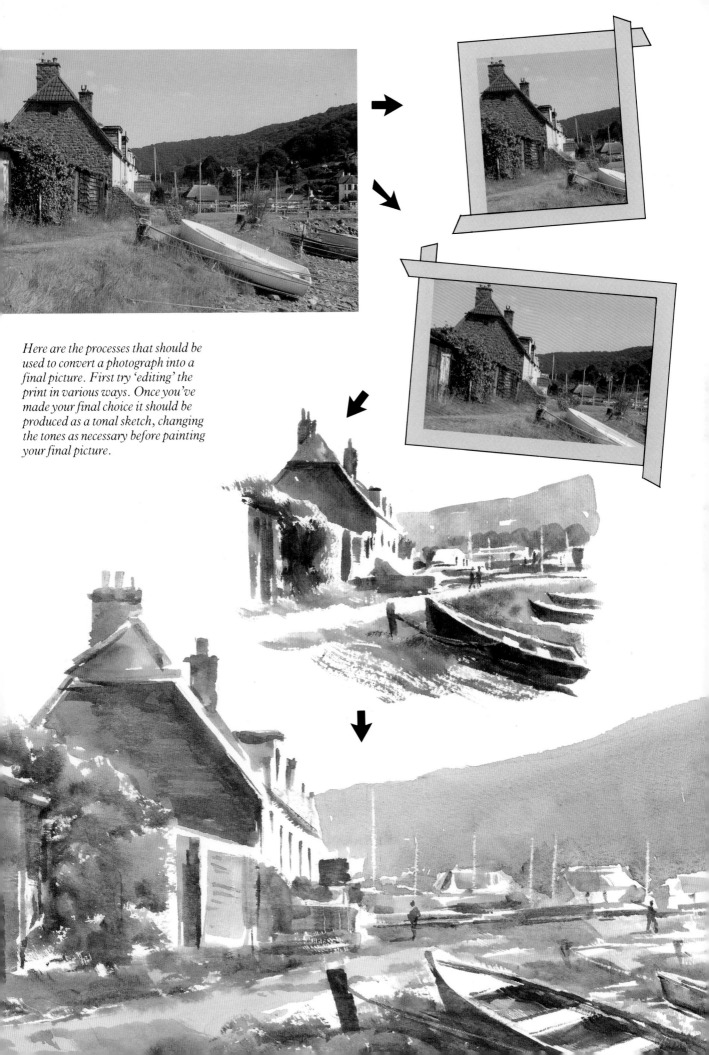

Here are the processes that should be used to convert a photograph into a final picture. First try 'editing' the print in various ways. Once you've made your final choice it should be produced as a tonal sketch, changing the tones as necessary before painting your final picture.

# Controlling colour

*Raw Sienna*

Like everything else in this book I'm going to try and discuss colour in very basic terms. As I said, I always start my students off by using Burnt Umber only, to make them understand tonal values. The trouble really comes when they start using colour. At first, everything they've learned up to that time gets forgotten. It's the relationship of tone with colour that gets so confusing.

I've made it as simple as I can by restricting myself to only seven colours, and in most paintings I use only about four or five of these anyway. Let's take these seven colours one at a time.

*Raw Sienna.* This is my 'banker'. It's very versatile and I use it on every painting. It's an 'earth' colour – one of the oldest colours known. I much prefer it to Yellow Ochre as it's much more transparent.

*Bright Yellow.* I hesitate to say lemon yellow, which is on the label of the particular brand I use, because I found that in some other makes and ranges it turns out to be a rather opaque creamy yellow. Just get the brightest purest yellow you can—Cadmium Yellow is probably the safest.

*Burnt Umber.* Another 'earth' colour, which is very useful for making a whole range of greys when mixed with Ultramarine.

*Ultramarine.* This is a very strong rich blue. I hardly ever use it straight as it can look crude, but tempered with other colours it's delightful. For example, mixed with Light Red it makes lovely warm shadows.

*Light Red.* This is a very fierce 'earth' colour—a little of it goes a long way. Never use it without adding another colour such as Raw Sienna. Use it with discretion on autumn scenes.

*Alizarin Crimson.* Again, a tube of this lasts a long time. It's a cool intense red and very useful for tempering down Paynes Grey for clouds.

*Paynes Grey.* Some artists wouldn't be seen dead using this colour; I love it! Never use it by itself: it looks cold and can easily dominate a painting, but applied sensitively and warmed up with colours like Burnt Umber it's valuable. I use it also with yellow for my dark greens. It dries much lighter than it appears when wet.

My personal theory is that by being so frugal with the number of colours, one gets to know them intimately and to understand how each reacts with the others. Those elaborate presentation boxes with rows and rows of anonymous pans fill me with confusion and dread. Also I need instant availability of copious quantities of the stuff, and don't want to lose my concentration by having to scrub at pans or hard paint left over from yesterday.

*Bright Yellow*

*Burnt Umber*

*Ultramarine*

*Light Red*

*Alizarin Crimson*

*Paynes Grey*

ABOVE
*A nice range of ochres can be obtained by mixing left, yellow and Raw Sienna; centre, Burnt Umber and yellow; right, Burnt Umber and Raw Sienna – all very useful for autumn scenes.*

ABOVE
*These are the basic combinations for greens but they can be varied widely depending on the proportions, as can be seen overleaf. Left, yellow and Ultramarine; centre, yellow and Paynes Grey; right Raw Sienna and Ultramarine.*

ABOVE
*You can make quite a range of subtle reds with these combinations. Left, red and Raw Sienna are great for Mediterranean terracotta roofs; centre, mixing yellow and Light Red results in a gentle orange; right, yellow and Alizarin Crimson put together will produce a reasonably bright red – although I find I very rarely need a bright pillarbox red.*

This is a watery distant green, mostly Ultramarine with just a touch of yellow.

Here we're starting to add more yellow to the blue, and using less water.

This is where things usually get too weak. Keep adding more yellow and reducing the water content until you get to really bright yellowy green.

I regard paint like mustard—it has to be freshly squeezed out, juicy and plentiful. Anything else and you're not giving yourself a chance. I often ask myself why students are so mean with their paints. I know that part of it is the fear of wasting expensive materials but when you think of it, the cost is absolutely infinitesimal in relation to some of the painting courses they go on and the fortunes they spend on books!

My own philosophy, then, is to use only a few colours, but plenty of paint and a lot less water. Most students use too much water and not enough paint, often resulting in miserable, weak, washed-out paintings.

What I'm doing above is to show you the various permutations of my seven colours and, very importantly, how to make a range of greens. There are, of course, hundreds of different greens and even more ways of producing them, but I've found ordinary students are often scared stiff of greens and so often let themselves down by using monotonous weak washes with little or no variation from the front to the back of the picture. Here then is a simple formula for achieving a complete range and the depth it can suggest in a landscape.

Just looking at these various combinations won't do you much good at all. Get your scrap paper out and try them out for yourself! You will soon get to the stage where you can look at a colour in nature and know instinctively how to achieve it in paint—it's only practice.

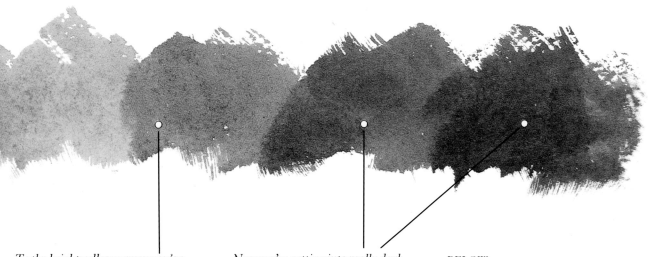

To the bright yellowy green you've made you start to add Paynes Grey very gradually, keeping the mixture rich.

Now we're getting into really dark greens. The secret is to have them strong enough to put them in first time and leave them alone – four coats will result in mud!

BELOW
This scene shows how the various greens can be used to give depth to a painting. The rich warm greens in the foreground are produced by adding Raw Sienna. They gradually recede and get cooler in the distance.

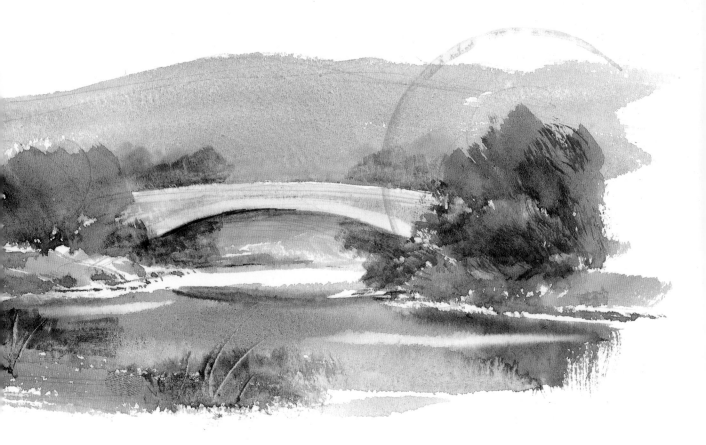

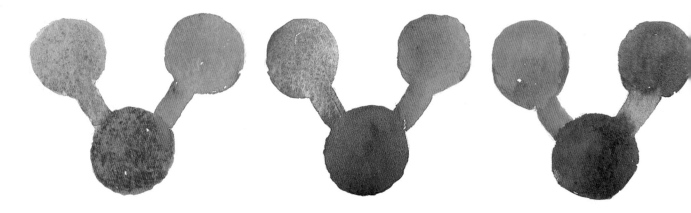

ABOVE
*Left, Raw Sienna and Alizarin mixed produce a very subtle red. Centre, Ultramarine and Alizarin Crimson used in different strengths can result in everything from delicate mauves to rich purples. Right, my usual mixture for cloud colours, Paynes Grey with a touch of Alizarin Crimson just to take the coldness out of it – but not too much: it's very subtle!*

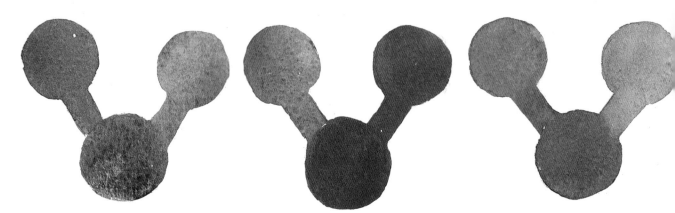

ABOVE
*You can get a nice olive green, left, by mixing Paynes Grey and Raw Sienna. Centre, Burnt Umber and Light Red result in a warm brown – my own substitute mixture for Burnt Sienna. Right, Light Red and Paynes Grey combine together to produced a very warm grey.*

ABOVE
*These combinations produce an almost unlimited range of subtle greys. Left, my favourite mixture for shadows, Light Red with Ultramarine. Centre, Ultramarine and Paynes Grey – the grey should be used just to take some of the brightness out of the blue. Right, by using Burnt Umber and Ultramarine in various proportions and strengths you can obtain a range of greys just by themselves.*

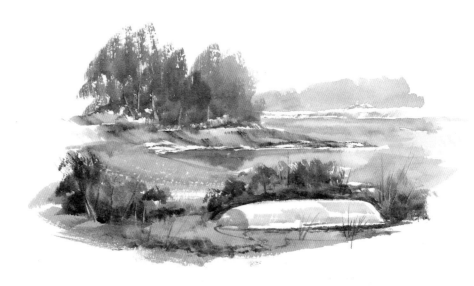

You can combine tone and colour temperature together to convey a sense of distance and space on a flat piece of water-colour paper. (I'm going to be very practical here and avoid talking about staining and non-staining triads. Many worthy books cover all this but I don't want to lose you by getting too technical.)

Let me try to explain about warm and cool colours. Basically, warm colours are those related to red, orange, yellow, and brown, and cool colours have blue in them.

In tonal values, we saw that light tones tend to recede whilst dark tones appear to come forward; we use this phenomenon to give an illusion of depth in our pictures—it's called 'aerial perspective'. We take this idea a stage further when we come to using colour because colours in a landscape tend to cool with distance, inclining gradually towards blue or blue-grey. You can barely see this in real life, but as an artist you can slightly exaggerate it to your own advantage. Even in an interior, objects on the far side of a room should be painted slightly cooler than those in the front—though in reality you hardly notice it. I must admit I exploit this a lot, especially in the use of greens.

ABOVE
*Another example of the use of the various greens to give depth.*

BELOW
*A very simple little Austrian sketch done on my first skiing holiday last year. Again I've tried to suggest distance by using both tone and colour.*

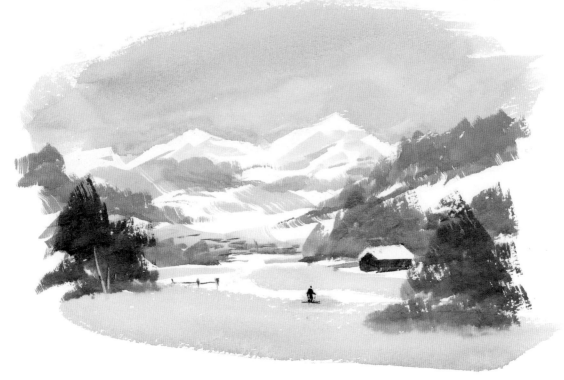

# Solving skies

There's no doubt about it, painting skies in watercolour is exciting. You've got to work fast and decisively. There's absolutely no point in worrying and poking them afterwards to try and rescue them; if they haven't worked first time, start again.

When I'm doing demonstrations, generally I chatter away all the time I'm working, until I come to the sky. Then there's silence. I feel a bit like an acrobat in a circus. I warn them that it's going to take about a minute, and then we all hold our breaths. One can almost imagine a roll on the drums, and the hake flies. In thirty seconds I know in my bones whether it's going to work or not. You've always got to frighten yourself doing skies; in my case that includes most of my audience too! They see a strong dark colour going on, and they think, 'he's ruined it', but fifteen seconds later it's diffused and dried back to a reasonable strength of colour.

The main faults of my students' skies are easy to see. They're usually far too weak and anaemic all over through lack of courage. In their wet-into-wet skies, their second lot of paint is invariably too wet and runny, giving absolutely no definition of clouds at all. Lack of decision keeps them fiddling long after they should have stopped. Many of the skies are completely unconvincing because they've just put on vague patches of blue and grey without any real knowledge of cloud formation, trusting mainly to luck that something reasonable will come out of it.

Once you've got over that initial fear of spoiling the paper, skies aren't all that difficult—it's mainly a question of confidence. The only way to get them right is to practise them over and over again, saving the backs of your failures (we all have them) to practise your skies on. Skies are a bit like a high diving-board, the more times you jump, the less scary it gets.

Rather than consider the various types of cloud formation such as cumulus or stratus, I think it's far more important that you should first get into the right frame of mind about tackling them. It's always incredible to me, how so many students are completely ignorant about cloud formations. I hope this isn't sounding too pompous. One doesn't even have to study a book about them either, just raise your eyes and look! I'm constantly having to explain that white cumulus clouds are like pieces of cottonwool under a spot-light, with a shadow underneath them, and that basically, clouds are large in the foreground and get smaller as they recede towards the horizon.

The great English artist Constable, and later my own personal hero, Edward Seago, used to do lots of quick paintings of skies every day, just to learn about them until they knew them inti-

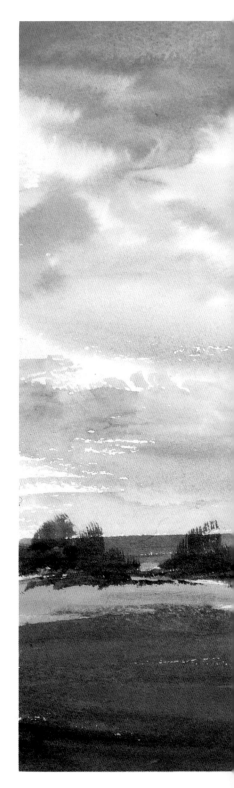

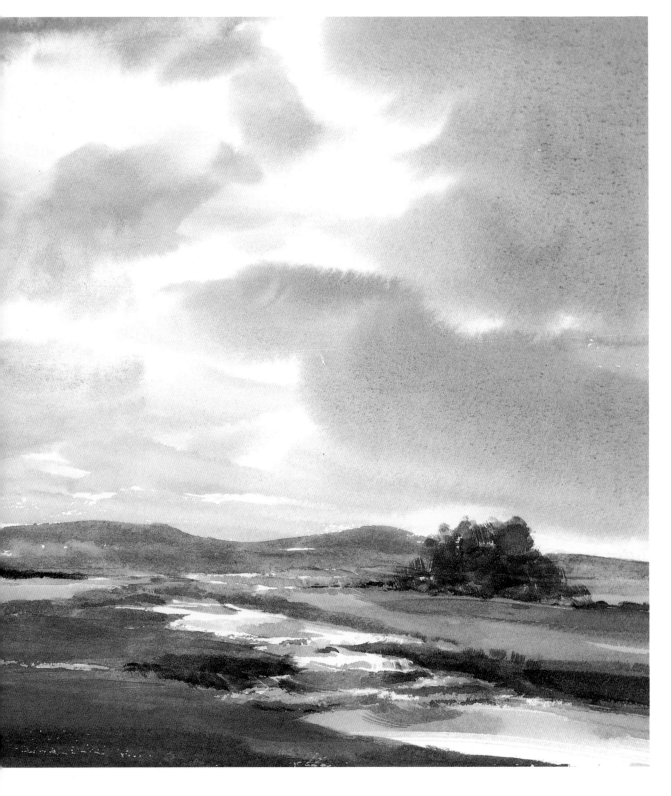

*A sky painted very quickly. A very weak Raw Sienna wash was put over the whole sky area, and the other colours dropped in immediately.*

mately. Sadly, most of us haven't got their dedication and drive, but if I can only persuade some of you to use all those odd scraps of discarded paper to produce lots of cloud sketches, it would do much more good than reading hundreds of books like this.

The hake is tailor-made for producing skies, quickly and easily. With practice you can make it dance, light as a feather, over the paper, covering it in a fraction of the time an ordinary sable would take. I've tried in my paintings here to give you a variety of exciting skies to underline what I'm saying. If I can't persuade you to render real skies regularly, at least try copying some from this book. As I've said before, don't copy them mindlessly; try to understand, as you go along, just why a shadow on a cloud is underneath and not on top.

Let's go through a few procedures for various types of skies. Generally my own method, or perhaps, habit, is always to put a very light wash of Raw Sienna over the whole sky to 'lubricate'

BELOW
*Here's a very windy day with fluffy cumulus clouds. These studies should be done quickly to keep them fresh and lively – the tricky bit with this sort of picture is the water content: not too runny.*

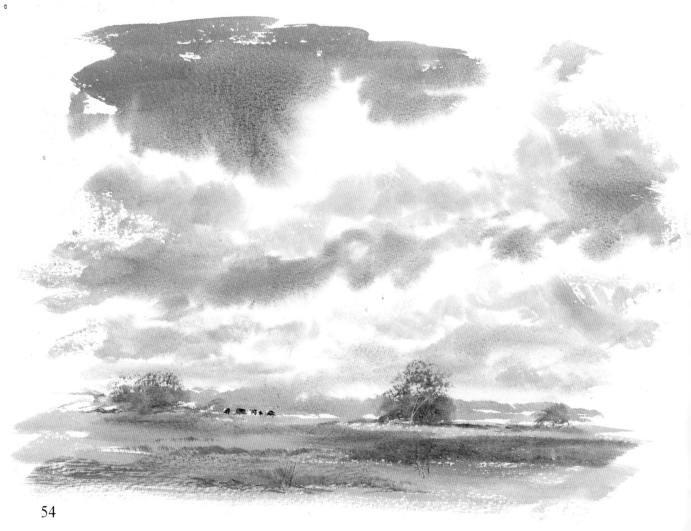

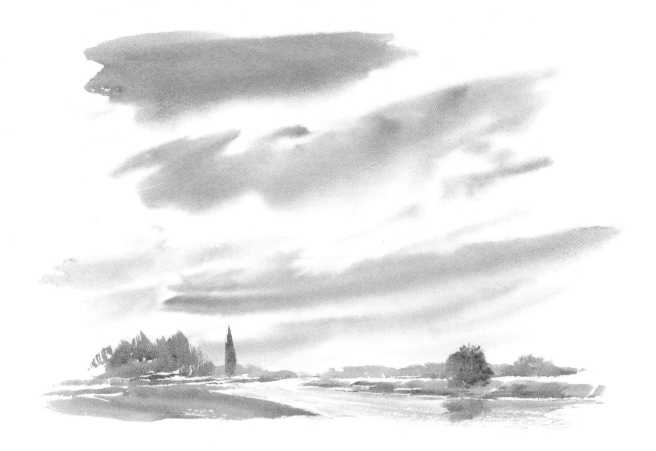

ABOVE
*These are high cirrus clouds – very easy, but again the timing and water content need practice. They're great fun to do and the landscapes below can be pure imagination.*

it, so to speak, just seconds before I attempt any weather condition. This shouldn't be too strong and bright, but a hardly discernible cream colour. It's important not to drench the sky with water; it should be just damp enough to be controllable and yet still allow diffusion of your cloud shapes.

Let me say at this point, it's the water content throughout a sky that makes it either a success or failure. I can't show you this in a book, but you'll just have to learn it by trial and error, mostly error, I'm afraid! This original cream colour represents the tops of the cumulus clouds or the bottom of a clear blue sky or the cream lights in a wet grey sky. In other words, it's the foundation for anything I choose to throw at it, seconds later. So let's start with that clear blue sky, the easiest of all to do.

By the way, for all my skies I work at an angle of about 45 degrees, thereby using gravity to help me. After you've put on your first thin wash of Raw Sienna, immediately mix up some Ultramarine, stronger than you feel you need. Now put one full rich stroke of the hake across the top. It will probably frighten you and look too dark, but carry on regardless, moving the brush backwards and forwards going down the sky, gradually taking the pressure off. When you're three-quarters of the way down it comes off the paper altogether. Gravity will then do the rest, leaving an almost creamy skyline. Within about thirty seconds the whole thing will have dried off and will look right in tone. Even if it still looks a bit strong, by the time you get the rest of the picture done, with a few darks, everything will have dropped into place.

Next come cirrus clouds in an otherwise blue sky. These are wispy, high clouds often called 'mares' tails'. The procedure is almost the same as rendering a blue sky, except that the blue

is put on at a slight angle leaving bare cream streaks showing at intervals. These should get narrower and closer together as they reach the horizon to show perspective. The hake hardly touches the paper by the time it reaches the horizon.

Now to cumulus clouds which are my own personal favourites. This is where life gets a bit tricky! They're those lovely heaps of billowing cream clouds with shadows underneath. They vary enormously in size – the one nearest to you, overhead, can take up to half the sky – and they reduce rapidly as they go further into the distance, giving a wonderful illusion of depth — all very exciting. However, a common mistake I see practically every day is identical-sized clouds all over the sky looking like a lot of sheep hanging on a vertical blue sheet.

The next thing you have to realise before you start is that you're not going to paint the clouds themselves, you're going to paint the blue negative spaces round them. Don't try to paint blue clouds on a cream sky which I've often seen done. Make up your mind first where you're going to put your clouds, in other words, mentally design your sky. Remember before you start, too, that cumulus clouds are bulbous and rounded at the top, and flatter at their bottoms, Now, take a deep breath, and begin.

First, apply the cream wash of Raw Sienna, not too drippy or you'll lose all your shapes, then mix up a rich mix of Ultramarine, and paint the spaces between the clouds quickly and lightly. Again, make the brush hardly touch the paper by the time it reaches the horizon. Don't sit back and admire your work, there isn't time! Immediately mix up a wash of Paynes Grey and Alizarin, with just enough Alizarin to take the coldness out of the grey but not enough to make it look mauve or pink.

With the original cream wash still damp (I said you'd have to work fast!), lightly touch the grey mixture on the underside of each cloud, leaving the sun-lit top edge against the blue sky, then leave the sky to settle down by itself. Don't poke it or touch it up, or you'll destroy the freshness. You'll probably find your first attempt will be too wet and runny, but do persevere, all you need is practice.

Many painters use white tissues to dab clouds out. Use them if you must, but I hardly ever do, because I think the less you disturb and torture the surface the fresher it looks, and one can always tell when tissues have been used on a sky.

Most skies don't fit into neat pigeon-holes, they're often a mixture of different cloud types at different levels at any one time. One of my favourite skies, is one with a patch of blue

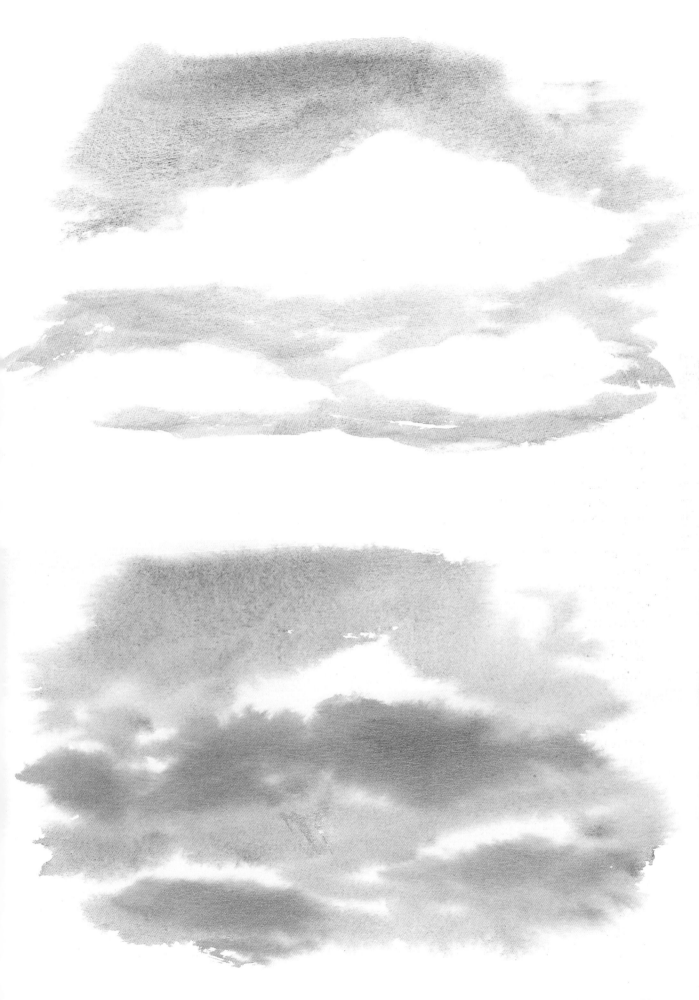

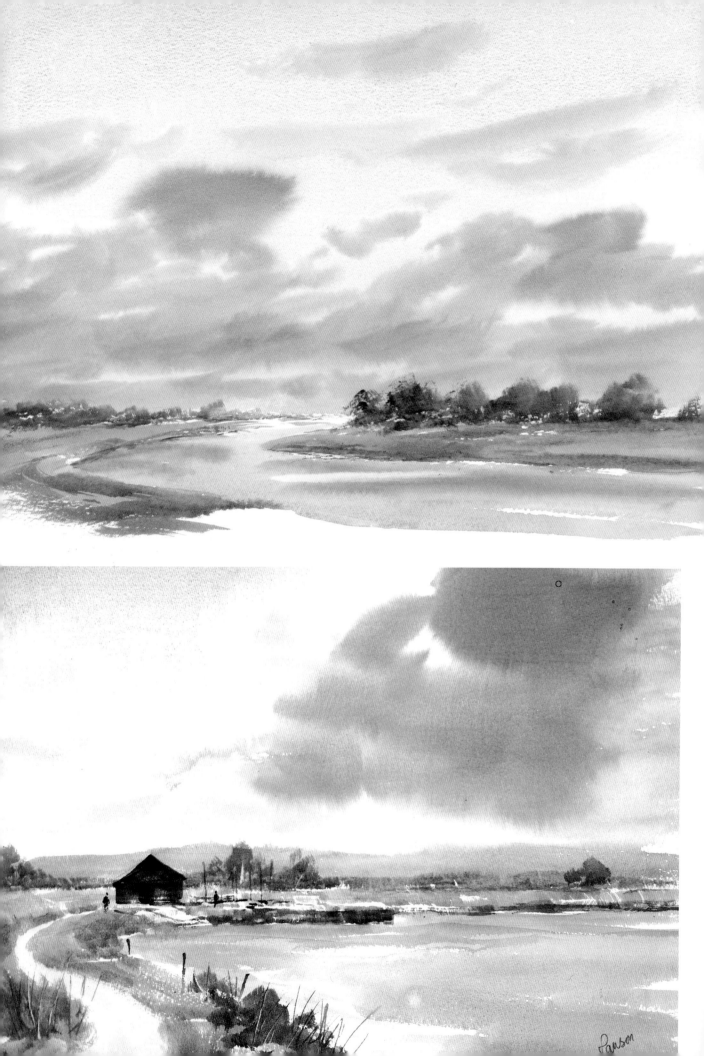

sky, a bit of cream cumulus and a threatening grey nimbus stratus (rain cloud) coming up. You can even paint a hillside up into the latter while it is still wet, to look as if it's raining on the hills. Again, the dark clouds should be put in boldly and fearlessly, and then left strictly alone to settle down the 45 degrees' slope.

Another quite easy sky to paint, is a stormy overcast one with receding and diminishing layers of cream and grey wet-into-wet. If you want to create the impression of pouring rain underneath the cloud, tip the board almost vertically to make the wash drop down before it dries.

I've already told you to leave skies alone while they are damp, but after you've done this and they're completely dry, you may still be disappointed because they're too weak. All is not lost, however. You can dampen them over with clean water, and work on them again. It's only the half dry half wet state that is so critical.

In this chapter I've deliberately restricted sky colours to three or four in my descriptions of techniques but as you progress and gain confidence, feel free to use a wider range of colours such as pinks and mauves, especially in your dawns and sunsets. Skies are not just a backdrop to your landscapes, they are an integral part of them, governing the whole mood of the picture.

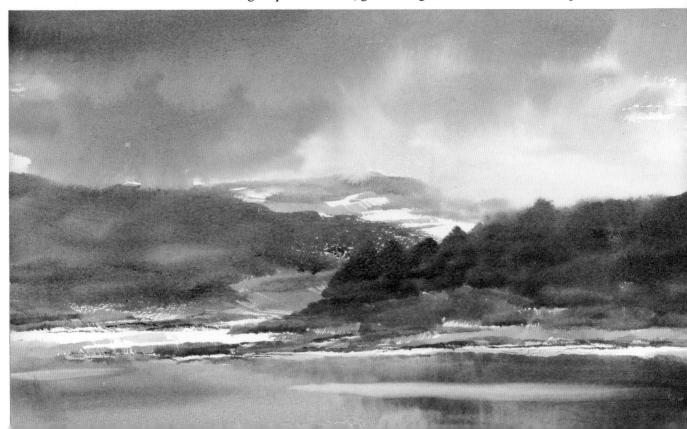

# Ways with water

Water in all its moods and settings is a constant source of subject matter for the watercolour painter. You can't get away from it anyway, as it covers about seven-tenths of the world's surface. However, it's elusive and challenging stuff to paint because it's always changing. You may be sitting by a river or lake and the water seems calm and passive, reflecting everything around it. A minute later, a slight breeze comes along and all our reflections have gone, or at least have changed their appearance. A stiffer breeze will change the water again, creating small waves which will then have to be depicted in an entirely different way. Trying to capture the movement of a fast-flowing brook or rapids is, for me, an even more exciting task.

All these various watery moods can be depicted simply and convincingly in watercolour by using various techniques. First, get away from the usual beginner's trick of putting a few strokes or 'ripples' on a blue wash—that's not going to fool anybody into thinking that it's water! What you're really trying to do is to symbolise water in its various conditions, but before you can do it with conviction you've got to understand what causes the changes. The trouble is that students hardly ever sit down by a pond or stream and really study reflections and light. Just for once, leave your paints at home and try it—it all comes down to observation, which is just as important as painting technique.

So let's go back to square one and think first of a sheet of calm motionless water. It's basically colourless stuff, reflecting things around it like a mirror. Devoid of any surroundings except sky, it would just reflect the sky colour. That sounds simple and logical doesn't it? But many beginners seem to fall down even at this first hurdle, and paint the water blue, whatever

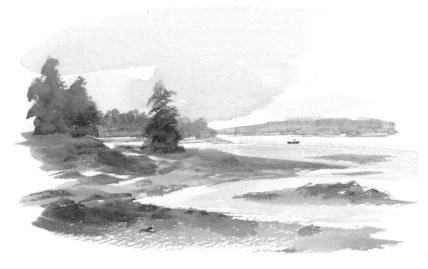

*A fast-moving river scene in Scotland. Notice how much of the paper is left untouched to give the impression of tumbling water.*

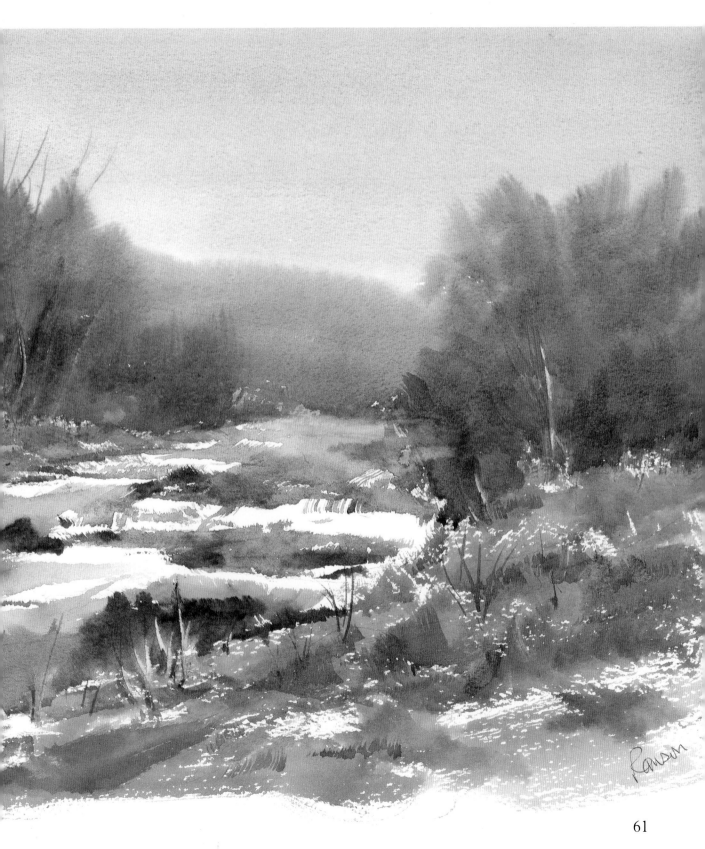

the weather conditions above. They forget that a stormy sky would, inevitably, produce a grey surface, and a yellow dawn sky would, when reflected, leave the river, itself, yellow.

Now to the tone of the water. It always looks better as graduated wash, darker at the front, and gradually getting lighter as it reaches the background. Even this has a reason, because, as we look at the water in the foreground, we see the dark bottom of the lake or river. However, as our eyes view the water in the distance, the more acute angle means more of the light sky is reflected.

Now let's add some surrounding objects, like a river bank, a tree, and possibly a post to the far side of the water. In theory,being a mirror of its surroundings and in perfectly calm conditions, one would see an extract reflection of these things upside down in the water. However, the surface is nearly always disturbed slightly by a faint breeze or flowing current, so the reflection always appears slightly blurred. On top of these reflections one usually gets lighter areas, where the surface has been ruffled locally by a slight wind that disturbs it, and the tiny ripples reflect the sky.

Having understood the reasons, let's get down to the actual technique. Using the hake, I first put in a graduated wash of the sky colour, using horizontal strokes. While this first wash is still fairly damp, I put in the reflections with vertical strokes using rich strong paint to compensate for the water already on

OPPOSITE
*A simple way of showing calm water. First the water should be painted in, more or less mirroring the sky colour. Then while it's still damp drop in the tree reflections in strong paint, making sure the shapes match. Finally wipe out the ruffled water with the edge of a thirsty hake.*

BELOW
*A calm lakeland scene with the distant hills reflected in the surface. Note, too, the dark reflection of the foreground trees in the water.*

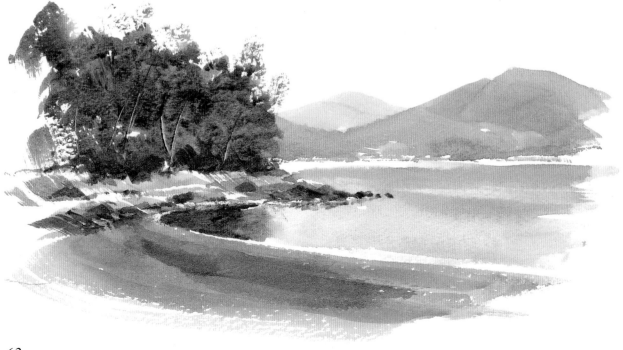

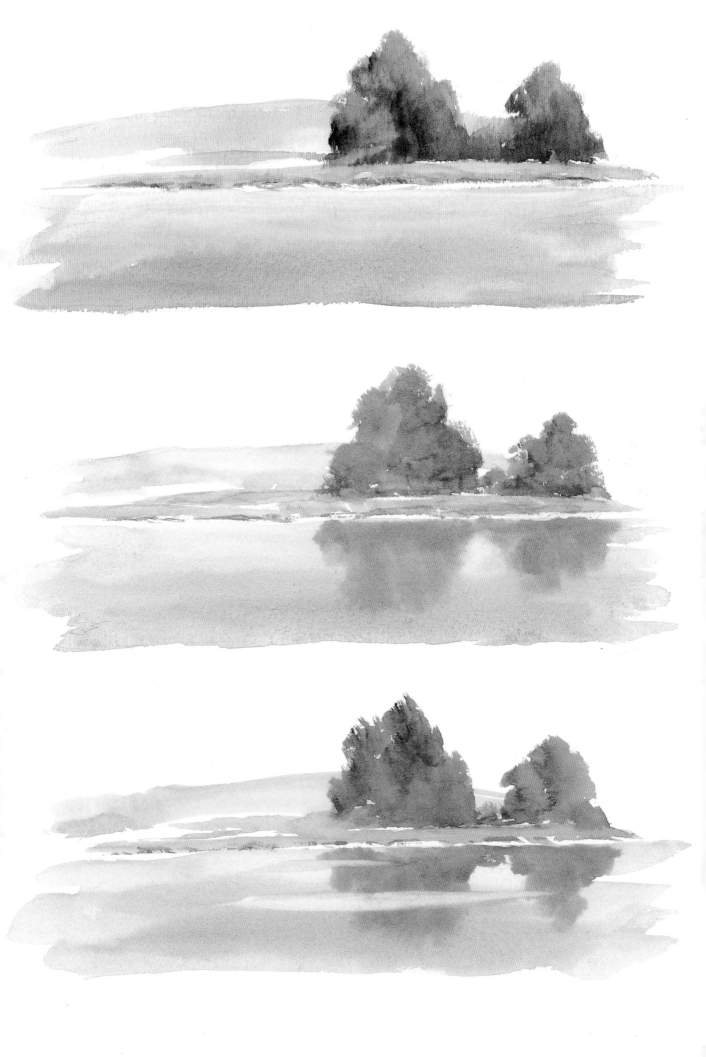

**ABOVE**
*First put in your graded wash with horizontal strokes of the hake. The sparkling effect of sunlight on water in the distance can be got by quickly and lightly sweeping the brush across at a low angle to the paper.*

**BELOW**
*Now, whilst the first wash is still wet, sweep across some streaks of slightly richer darker paint and wipe out one or two streaks with a dry hake – but only in the foreground. Don't go too far back. There are no distant reflections and near ones 'wriggle' sharply.*

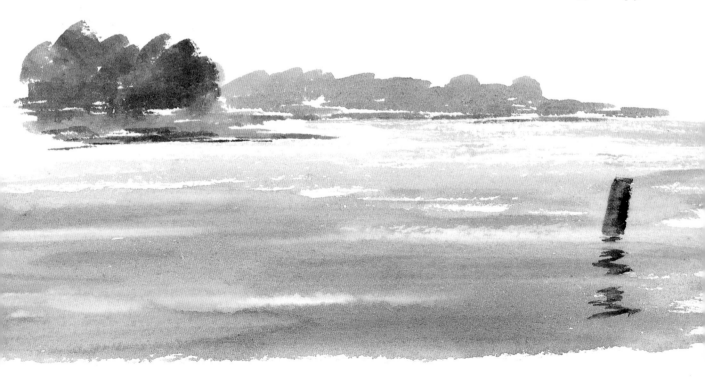

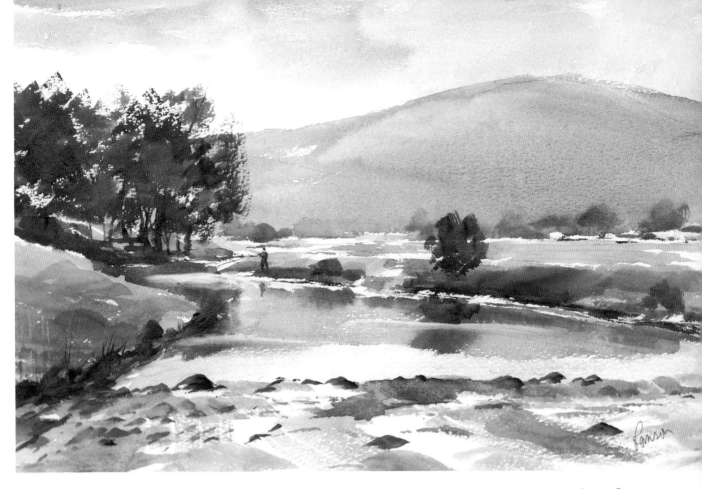

ABOVE AND BELOW
*Here are a couple of examples of calm and broken water. Where it breaks up over the shallows, move the brush very quickly in the direction of the flow and leave plenty of untouched paper.*

the paper. Because they're put on still damp paper, the reflections will become soft and slightly blurred at the edges, but the paint, being rich, will retain more or less the same tone, colour and shape as the objects that caused them.

Another point to remember is that if the objects are right on the water's edge, the reflections will be about the same length, whereas an object some way back from the edge will produce a much shortened reflection. For example, a large tree a field away may just show up as a rounded top. In other words, the height of a reflection is measured from the base of the object itself.

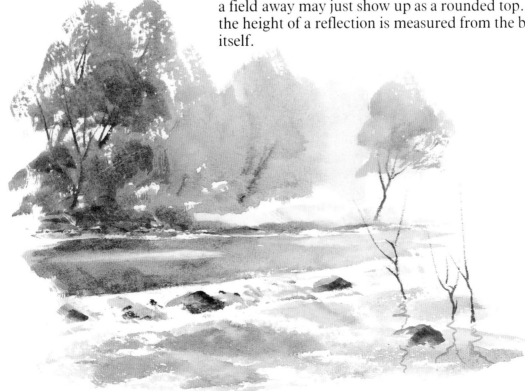

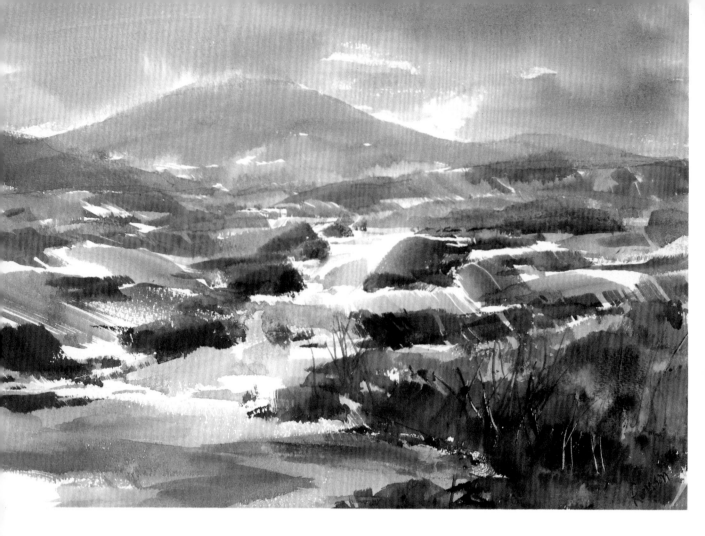

Finally, having put in the reflections, but still before the surface has dried, I put in the light streaks on the water. I wipe my hake on the rag to make it 'thirsty', and then slowly and deliberately, wipe out the horizontal lines, putting more pressure on the middle of the stroke and bringing it off at each end. It's much more dramatic and effective if it's done over the dark reflections rather than the lighter parts of the water. A warning—don't get carried away with the streaks; one or two on a stretch of water in different sizes is usually enough.

Now let's look at a more windswept body of water. It still, basically, reflects its surroundings—light tones for the sky, and dark tones for the landscape, but as the tiny waves are formed, the angle on the surface of each wave is changed so that it reflects another part of its surroundings. One part of a wave, perhaps, reflects the light sky towards us, whilst another part may reflect a dark object nearby. In these conditions, distant objects may cease to reflect at all, because of the corrugation, whereas near reflections of such things as a vertical post in the foreground may no longer appear as a soft upside-down image, but as a hard-edged, staccato, wriggling shape, broken up at intervals, where the angle of the water reflects the sky. You can see, now, why it's important to know the reasons for the various marks you put on the paper, rather than paint them in mindlessly, just because you've been told to do it.

So now let's look at the actual technique for rendering water with some movement—a fast-flowing river or a breezy lake, for

ABOVE
*This is a demo I did in Galway, Ireland. The picture itself is weak and flat in the background, and strong and contrasting in the foreground, leaving much untouched paper to indicate the tumbling water.*

BELOW
*This is the River Wye very near to my house. I first painted in the river in sky colour and then quickly dropped in the various reflections – first the distant hill, then the two banks of trees in strong paint, and finally the streaks, which are more effective on the dark areas.*

instance. Again, start by making a graduated wash of the sky colour with the hake. Here, one of my favourite tricks is to get the illusion of sparkling sunlight on distant water by holding the hake at an acute angle to the paper, and brushing it quickly across with the lightest possible touch so that the paint misses the tiny indentations of the paper. You'll see many examples of this in the book.

Having got your first wash on, you can forget about distant reflections and, instead, concentrate on getting the foreground swells. While the original wash is still wet, wipe out a few light streaks with a dry hake, but this time, don't usually use the

fine edge of the brush, use more of the side to get a wider, softer streak. In between these, add some darker streaks, mixed with richer paint, still before the first wash has dried. Again, don't overdo it; a few strokes in the foreground will be sufficient, and these should rapidly diminish in size, disappearing altogether, about half way back, to get the illusion of depth and distance. You'll still get some foreground reflections, but as I said, they should be hard edged and wriggling. Reflections around foreground boats in moving water are exciting to paint, but don't be in too much of a hurry with these. Study their repeating patterns for a few minutes before you put them in.

Now let's talk about faster moving waters, such as a brook tumbling down a hillside over submerged stones into flat pools, which in turn drop down to the next level, and so on. The pools, where the surface is smooth and mirror-like, reflect their surroundings, and where the water drops over the stones, take on some of the stones' colour. There's a feeling of tremendous surging energy as the white water foams down. A subject like this needs good composition. You should give it a lot of recession by using perspective to make the stretches of water narrower and smaller towards the background. Brooks and rivers don't usually flow straight, but curve and zig-zag, giving more rhythm to the movement.

When I'm working on a subject like this, I usually paint all the surrounding terrain first, leaving a gap for the stream or river. Then I take a deep, deep breath and paint the river in as fast as I can, using quick, light strokes, and leaving plenty of white paper for the foam. In this sort of picture, the horizontal

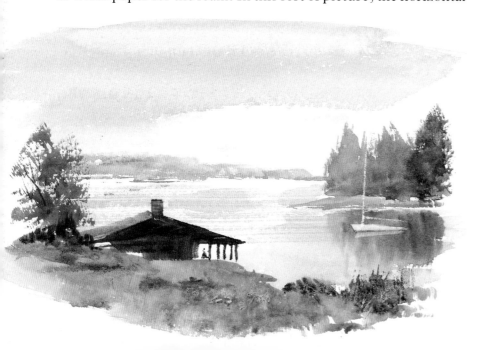

*An estuary scene in Devon. I scratched the masts and seagulls out very carefully once the painting was dry. The foreground I put in with a very quick light sweep of the hake to leave some sparkle on the paper, adding a little texture afterwards.*

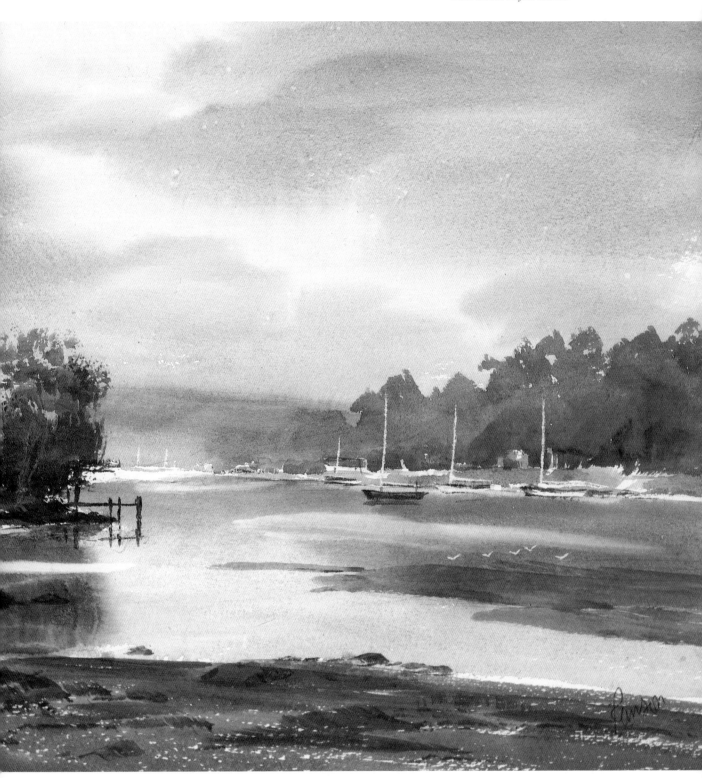

pools are important to counterbalance the complex movement of the cascading water. Without the calming effect of the pools, there would be just too much of a jumble.

Having tackled streams, rivers and lakes, let's move on towards the coast and talk about estuaries, harbours and the sea itself. Estuaries are great subjects for watercolour, and the use of the hake in particular—lots of sky, peaceful stillness and mud. They are also one of the easiest subjects to tackle. The secret is to paint them simply and directly, give them a nice low horizon and you can really go to town on the sky. There probably won't be much happening in the foreground, so the sky itself can be quite dramatic. The estuary can be painted with a few sweeping strokes of the hake, making sure the curves flow well. Try to put variety into the colour of the sandy beach with various mixes of Ultramarine, Burnt Umber and Raw Sienna. Any texture which you may put in on top should be confined to the foreground, and even then should be added swiftly and economically. Even though you're actually depicting mud, the washes themselves should be pure and transparent.

The odd posts that you find in these sort of scenes make good vertical features and their reflections help a lot too. You can also add a few distant sailing boats, left high and dry at low tide, with their masts at different angles. The posts and the masts can both be indicated with light touches of the 1in brush. By tipping the brush slightly on one side, you can produce shorter lines with it. The corner of the brush can be used to

*This is a misty morning on the coast of Maine, USA. In the painting I first wet the whole paper, and then gradated the water and sky at the same time, before indicating the distant shore. The pier and boats and so on were put in with the 1 in flat brush when the first washes were dry.*

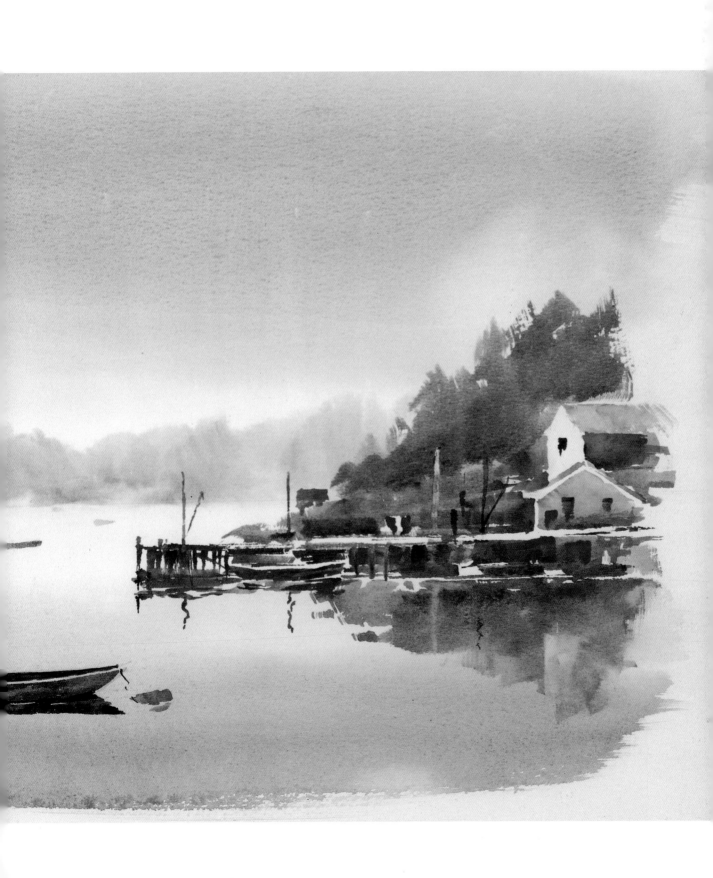

create a wriggly reflection. Make sure the reflection of the sloping post or mast is at the correct angle. I've seen a lot of mistakes made here and it really takes some of the credibility out of an otherwise convincing painting.

Harbour scenes provide another range of subjects. These are often better shown at low tide, leaving interesting pools with reflections of boats, contrasting with the textures of the harbour bottom. Be selective—just because there are fifty boats on their moorings you don't have to draw them all. Pick on a few of the most interesting, try to get an unusual viewpoint in the harbour and don't always go for the conventional.

Now for the sea itself. I suppose, without being too simplistic, we could divide most seascapes into two basic categories. Distant coastline panoramas and foreground-type pictures with waves crashing on rocks. When you're painting a distant sea, colour variation is important. Don't make the whole sea a flat all-over blue or grey from front to back with no change of colour, which one sees so often in students' work. While the sea may basically reflect the sky, the colour and tone of it can be much influenced by a variety of other factors. Unlike the waters of rivers and lakes, which I've talked about before, the sea can be dark in the distance and light in the foreground or vice versa. There may even be a dark streak in mid distance from the shadow of a cloud or a greater depth of water in that area. Add these colours and variations wet-into-wet on top of the first predomin-

*This is another painting done on the coast of Maine. I'd taken my students to a lighthouse but, having arrived, I liked the view facing the other way much more! I tried to portray the scene in as economical a way as possible. Note the way I've hinted at the distant houses by leaving gaps. I've also tried to vary the colour of the water surface. The photo was taken by a student while my back was turned!*

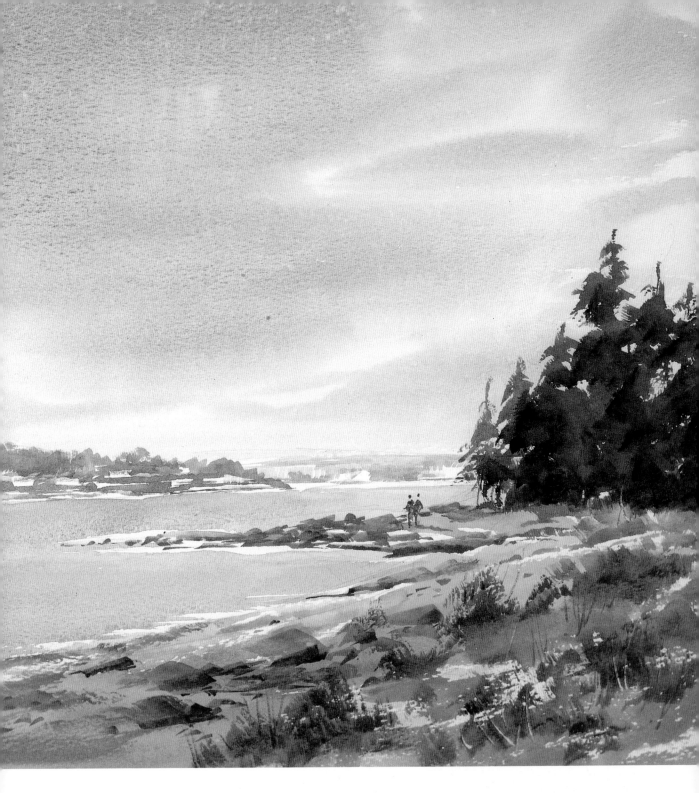

ant colour, which should be carefully and freshly put on, making sure that your horizon line is completely horizontal and giving a smooth sweep to the shore line, perhaps leaving some sweeps of untouched paper for the waves.

Foreground seascapes with rocks and crashing waves are very exciting subjects, but have to be done with speed and dash. The overall design of your picture here is very important so it's even more essential to do your tonal sketch first. You'll find, once you've established where your lights and darks are going to be, you'll be free to paint in a much more uninhibited way.

The soft foam and spray should be left as white paper to

contrast with the dark sharp-edged rocks, though afterwards when it's completely dry it can be softly and lightly moulded. Get plenty of colour variation in your sea from rich blue to yellowy greens. The general feeling should be of complete spontaneity; nothing looks so boring as static waves. The hake is in its element here and this sort of subject gives you a chance to use lots of wet-to-wet, contrasting with dry brush for the rocks.

Let's think for a moment of the wave shapes themselves. These are large in the foreground, smaller in the mid distance and perhaps disappearing altogether in the background. Another element in this sort of scene is the foam which lies flat on the surface of the water following its contours. As this light foam begins to dissolve at the edges oval-shaped holes appear in it which are the same colour as the rest of the water. Eventually the foam disappears into white rivulets.

Finally, as a general rule, keep the sky fairly simple if you're painting a rough sea, to create a contrast. A busy sky and a busy sea together will end up as a fussy painting.

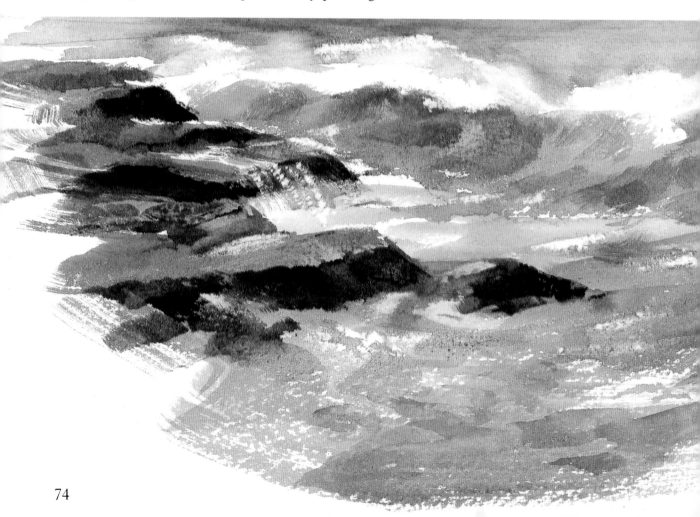

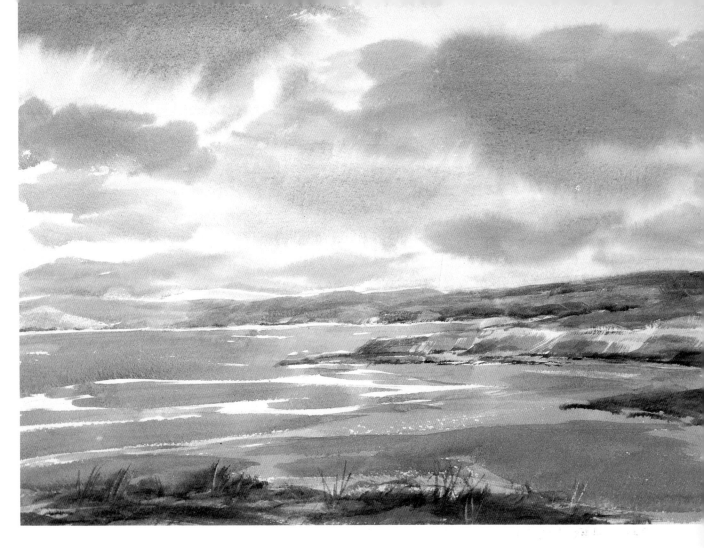

ABOVE
*A view of Cardigan Bay in Wales, where I run an annual workshop. I indicated the waves by leaving gaps in the wash as I painted the sea. I also tried to show the cliffs by doing diagonal strokes with the hake, again leaving untouched paper for texture.*

LEFT
*A rather wild attempt at showing surf breaking on rocks, which I feel needs to be done quickly, with abandon, to capture the movement of the water.*

# *Facing foregrounds*

The trouble with the foreground is that it is usually the last thing you tackle in a painting. So many students get uptight because they're afraid the foreground is going to ruin the rest of the painting and you know, it often does! There's no part of a painting which presents so many hazards. Literally thousands of potentially good paintings come to grief at this last hurdle. You've managed well with the sky, background and hills are just right, even the distant trees are put in perfectly, but then you come to the foreground, which finishes up as muddy, over-worked and indecisive. The trouble, of course, is again lack of preparation. You are hoping that by the time you get to the foreground, things will automatically fall into place themselves. You attack it without much thought. It doesn't seem to work,

BELOW
*This is in Galway, Ireland, painted during another workshop there. I really enjoyed this one, attempting to show the solidity of the rocks contrasting with the tumbling torrent through the direction of the strokes of the hake.*

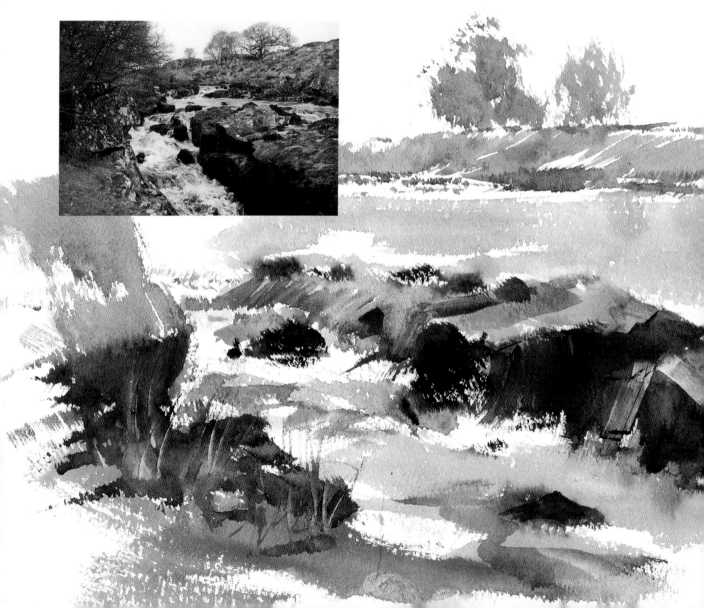

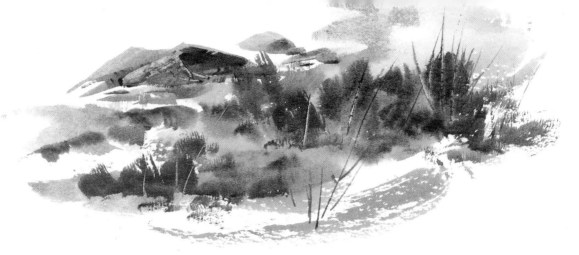

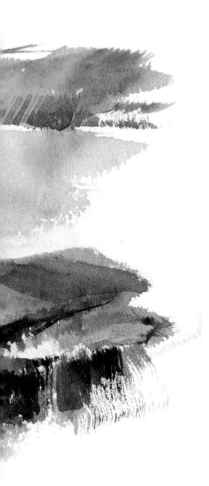

so you play around with it, layer upon layer, vainly hoping something good will turn up. What usually turns up is mud!

It is important to remember that your main centre of interest should have already been established, and counterchanged, or whatever other methods you use to highlight it. It doesn't need any competition for attention. Think of foreground as an entrance to the rest of your painting. As a matter of fact, if you are looking hard at the centre of interest in the actual scene itself, the foreground would be out of focus to your eye, and you would only see it as just a blur — try it!

The answer is always to keep the foreground simple and uncluttered. One way is to do it as fast as possible. Take your courage in both hands, and give one good sweep of the loaded brush. If it comes off, it gives the whole painting a feeling of vitality and direction. Of course, I'm not saying that you can always do a foreground in one sweep; it will also need a certain amount of texture to indicate the surface, whether it is a pebble beach, rutted path or coarse rough grass.

It's always a good idea to try your foreground out on another piece of scrap paper first, like a golfer who tries out his drive or putting stroke in thin air before he addresses the ball itself. What you've got to get into your mind is, that you can be incredibly economical with the way you treat your textures. Your viewer will easily understand what the surface is about, even if only 10 per cent of the area is actually textured, and the rest left as a completely flat wash. In the same way, three or four stones or bricks judiciously placed in a wall are indication enough.

Nothing looks so amateur or overworked as someone trying to show you every brick in a wall, every stone on a beach or rows and rows of carefully drawn blades of grass. Don't treat your audience like idiots! For some reason, students can admire and marvel at the economy of strokes, and the understatement of someone like Edward Seago, and the way his viewers are made to do much of the work of interpreting. However, as soon as they start their own painting, they feel they must put in every blade of grass, or no-one will understand their work. To me, it's rather like those tortuously explained captions under humorous drawings in pre-war copies of *Punch*. Since then, the captions have got shorter and shorter — and funnier!

Having said all this, let me try and show you how to tackle objects normally occurring in foregrounds. A bête noir for many

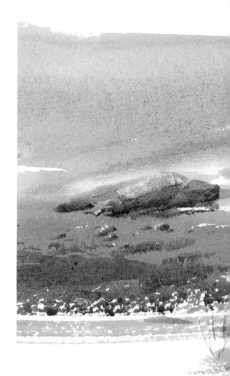

students is rocks. They appear in so many foregrounds, whether in landscapes or beaches, that you can't really ignore them. However, most amateur painters haven't really got much of a clue as to how to tackle them. They either paint them like cardboard cut-outs, without any third dimension, or make them look soft and round, like cotton wool. Rocks are heavy, hard and solid, and you've got to get this firmly in your mind from the start.

Before you even get your brushes out, you must spend some time just looking carefully. The top of the rock facing the sky is always the lightest part; sometimes it can even be left as white paper. The sides of the rock are darker, and the part facing away from the light source is even darker still. This is basic common sense, and if I was talking about a box, I wouldn't even have to tell you all this — you'd know! So from now on, think of them as boxes. With this in mind let's venture a little deeper.

As we've said, rocks are heavy, and to get the effect of them resting solidly on the ground, or rising out of it, you should make the edge between the ground and the rock soft and indistinct, in contrast to the hard contour of the top of the rock. You can also make them lighter in tone at the base to give the impression of light bouncing off the ground. Cast shadows of trees and other objects around are also very useful to show the shape of the rock itself.

Now we've got the shape sorted out, the next step is to add texture to the rock, I use a lot of dry brush for this, and for a large foreground rock, one quick light stroke with a dry hake will establish the top surface. The direction of the brush-stroke itself, horizontal for a top surface and vertical for the side of the rock, also helps greatly in describing the basic shape. A side stroke with a Stanley knife blade on still damp paint will also give texture and another technique, spatter, is sometimes useful.

Almost always make the maximum use of counterchange when you're painting rocks. If you've got a dark rock, contrast it against a light background to show off its profile, and with a light rock, use a dark background. If you're painting a group of rocks, counterchange the light top of a front rock against the dark side of one behind it.

With regard to the colour of rocks, they're not just brown or neutral grey all over, but have lots of subtle colour variations depending on the type of rock itself. The colour, also, is sometimes influenced by surrounding objects whose colour bounces

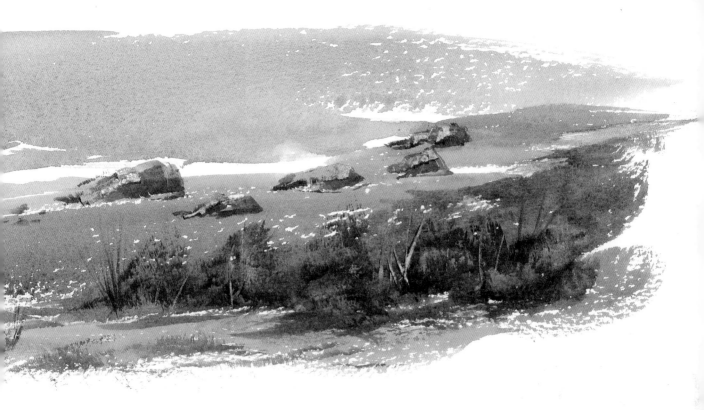

*A foreground from imagination showing seashore, beach, rocks and undergrowth in as simple, quick and economical a way as possible. The grasses are done with the rigger and also a fingernail in damp (not wet) paint. The sparkle of untouched paper on the beach is achieved by the quickness and lightness of the brush stroke.*

on the rock's surface. A different way of painting rocks is to paint the shape in with reasonably thick paint and wait until the paint is half dry, and then scrape off the light side of the rocks with an old credit card or a palette knife. Cracks and crevices between the rocks can then be darkened.

As well as the usual sharp-edged craggy rocks, there are others which have been rounded in shape by the erosion of sea or river, and these, of course, need to be treated in a slightly different way. First paint the shadow side, leaving the other side light. This can be contrasted against the shadow side of the next rock. The water shapes the top of the rocks, leaving a highlight. After you've put in the light and shade, add some texture with a dry brush.

You often need to paint stone walls in a foreground, and these can be a bit daunting. Don't attempt to build these up as individual rocks, which I've often seen done. The whole wall should be painted as a mass of varying colour, and only after this has dried do you need to indicate a few rocks within the surface. If you then add a bit of surface texture, this is usually enough to be convincing. Nothing looks worse than an over-worked wall.

Now let's come down in size and talk about pebbles. Pebbles are small rocks, anyway, that have been buffeted by water for countless years. When you're painting a foreground beach, don't try to paint the individual stones, It's impossible, and anyway, you'll only bore your viewers. Suggest them with a quick light sweep of the hake in slightly darker colour over an existing dry basic wash, followed, perhaps, by a bit of spatter work.

Although your pebbles are only small, some only pea sized, they do show up on beaches as areas of light and shadow, with warm colour in the light and cool in the shade, especially when the sun is low on the horizon. Spatter in small areas at the end is effective too, but don't overdo this.

*These three foregrounds really speak for themselves. Above, a typical rough field.*

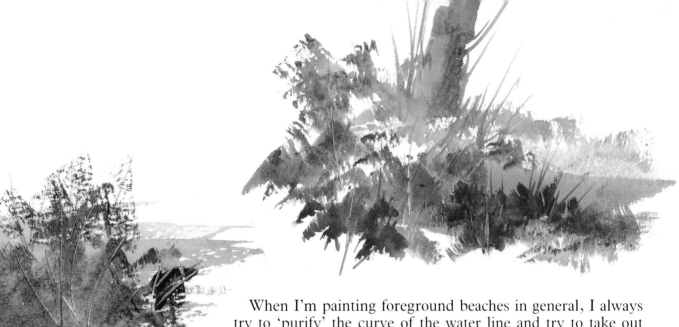

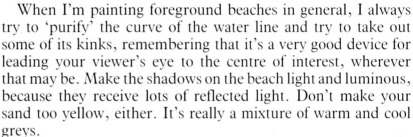

*Below and top right, the undergrowth in woodland. Note how you can quickly allow it to smooth out as it recedes into the distance.*

When I'm painting foreground beaches in general, I always try to 'purify' the curve of the water line and try to take out some of its kinks, remembering that it's a very good device for leading your viewer's eye to the centre of interest, wherever that may be. Make the shadows on the beach light and luminous, because they receive lots of reflected light. Don't make your sand too yellow, either. It's really a mixture of warm and cool greys.

Finally, don't make your beaches too light. It's sometimes difficult to judge tonal relationships on a sunny beach. Often you'll find the beach you first thought of as the lightest light, is actually darker than the sky.

Tall grasses and reeds are probably the most commonly used, and overworked, foreground subject, whether it's a grass field, a river bank or the undergrowth of a forest scene. Like much else in watercolour, these seemingly impossible masses of undergrowth can really be symbolised to everyone's satisfaction, including the viewers', if you can paint with the right attitude of mind. Take a foreground field or woodland undergrowth which starts at your feet and goes back into the distance, for instance. So much of it can be left plain and uncluttered, all the real textures can be confined to the absolute foreground, and quickly disappear to almost nothing as the ground recedes.

Put your general overall wash on first. This should be graduated from cool at the back to warm at the front, with perhaps a few darker areas to vary it. Now you can get your rigger out and put a few tiny flicks of grass about half way back, which will probably soften and become out of focus. As you come forward, and as the paint becomes slightly less damp, put in a few flicks of your fingernail, but not too many of these. I probably use the corner of the hake with rich paint just to suggest some texture. By this time the original wash is almost dry, so you can put in one or two more strokes with the rigger which will now be sharp and in focus, and the job is done.

I often feel that the shorter time you give yourself to do a foreground, the fresher and more professional it looks. A combination of the hake used at different angles with different amounts of water, combined with the rigger, flicks of the fingernail and even knuckles, can produce some very exciting foreground motifs.

# Tackling trees

This chapter could easily have been filled with a few pages of illustrations of various species of tree but I don't think this would be particularly useful and you can find that sort of information in plenty of other books anyway. Most of the time trees need to be portrayed convincingly, not as botanical specimens but as impressions in tone and colour, be it one or two single trees in the foreground, a group in the middle ground or a distant wood or forest. As watercolour artists we don't want to do much more than this — we're not photographers. It's our job to put over the atmosphere of a misty wood in the early morning, or the afternoon glow on a group of trees in the autumn.

Of course, the seasons play a big part in all this. Basically, we're talking about two separate groups of trees, coniferous and deciduous. Coniferous trees look the same in summer or winter, but most of the time we're painting deciduous trees, which lose their leaves and look entirely different when unclothed. What we're trying to do, therefore, is really to depict a sort of standard tree or trees, with and without the foliage. If you have to indicate a particular species, it's only a variation of this same standard tree.

Before we start on single trees, let's look at them as we usually see them in landscape, en masse and in depth. This is where so many students find themselves in trouble right from the start. They attempt to depict trees in the same colour and detail, whether they're fifty yards or a mile away. The most important thing to remember when painting trees is that the further away they are, the lighter, flatter and less detailed they become, and they also become cooler and weaker in colour. This is, of course, aerial perspective, and although I've said it all lots of times before, it still doesn't seem to sink in when it comes to trees. So many students start painting distant woods on the horizon in dark rich green, because they 'know' what colours they really are. They also know that there must be trunks there, even though they can't see them, so these go in too. The problem is then that nothing nearer can get much richer or more detailed, and the whole picture looks terribly flat.

I always try, in my landscape paintings, to exploit and exaggerate aerial perspective to make it much more obvious in the painting than it is in real life. I invariably depict my distant woods as flat tones. If I looked very closely, I could actually see variations in them, but I ruthlessly ignore these. The hake is a very good ally here as it helps me to avoid fiddling. As I move forward from an horizon to the middle ground, I gradually

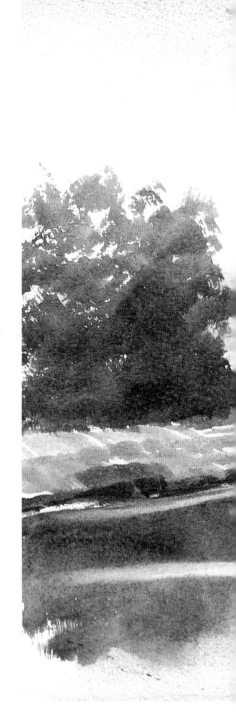

*This is another example of receding greens, the flat blue green of the distant woods gradually warming and strengthening to the trees in the foreground.*

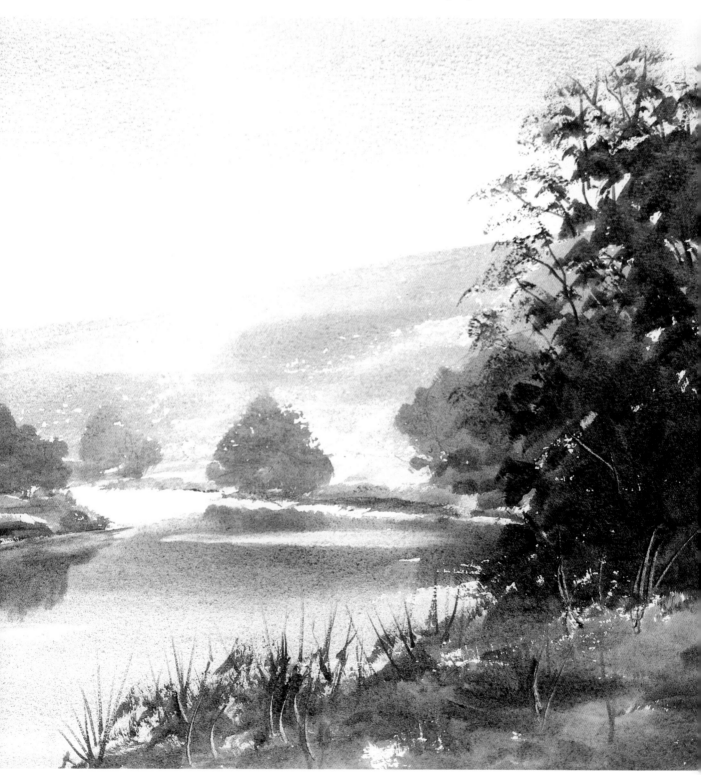

warm up my greens, by putting more yellow and less water in them, but only *gradually*. I've still got to reserve my richest greens and strong contrasts for my foreground trees. It is this restraint, this reining back, which many students find so difficult. They see that apparently bright green tree in the distance, and want to put it in as fierce as it appears, but it then sticks out like a sore thumb!

We've talked about greens in depth, but a similar process occurs in autumn and winter. The colours change, but the rules of cool and pale in the distance and warm and rich in the foreground still apply. In the autumn, the russets and light reds of the foreground can be made to recede by adding more water and more blue, resulting in an almost mauve tint to the trees on the horizon. In winter, distant woods can be indicated as almost blue/grey gradually warming up as they come forward to become brown/grey.

All this may sound very simplistic and elementary but if I could only get half my eager students to understand what I've just been saying about recession and, what is much more important, put it into practice when they're sitting in front of a landscape, their work would improve by 100 per cent.

Let's come to the deciduous tree itself. I don't for one moment

BELOW
*Winter woods. I've tried to avoid monotony by putting plenty of varied colour in the background wash. The white trunks were scratched out with my fingernail while the wash was half dry.*

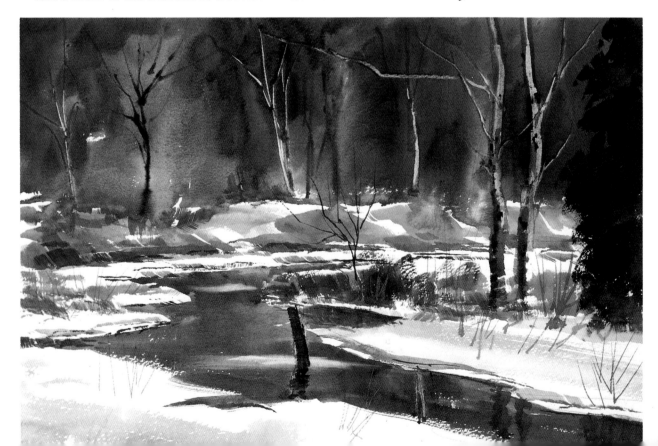

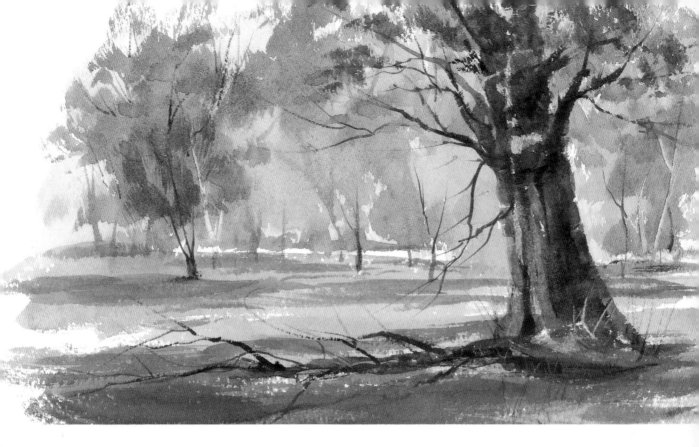

*This is a forest I visited in Western Australia. The light in it was hot and blinding. I've tried to convey distance by keeping the far trees very flat and simple. The strong warm shadow in the foreground helps too – it was made up of Ultramarine and Light Red, painted over a dry Raw Sienna wash.*

want you to think I'm saying you should paint all trees the same. Each and every tree has its own character and personality, even within the same species. I know there's no substitute for going out and drawing trees for months on end, but I also know that most people won't do it.

Trees are probably the most neglected forms in students' paintings. Why? Well, they've usually got a more complicated shape than any other element in the scene, and because they're so varied in form, we think that any mass of green will suggest foliage, and any old stroke will suggest branches.

Let's get down to the basic facts. The trunk grows out of the ground, usually in one piece, so is the thickest part of the tree. It always looks more solid and stable if you curve it out at the base. From the trunk grow the limbs, which are thinner than the trunk, but must be substantial, as they bear the main weight of the tree. Try to avoid making them leave the trunk opposite each other. The trunk itself keeps the same thickness until a limb comes off it, then it becomes less thick. The same thing happens as each limb leaves the trunk, until finally the trunk itself splits into the last two limbs. Limbs, themselves, split into branches, and the same reducing process goes on until the branches split into twigs, which run out from the branch ends.

It's this continuous diminishing of thickness from trunk to twig which is the most important factor in making a tree actually look as if it's a growing thing. This tapering and meandering of the trunk branches is a little different in each species of tree, but every tree has a distinct apex or high point. Try to make something that is more than a mere fan-like shape in two dimensions. Even the laciest of trees spreads out in all directions, and has a depth to it. Remember that the branches are coming towards you as well as from side to side.

In a close-up tree, I paint in the trunk and main limbs with the hake in various tones of grey, and while it's still wet, I touch in some darker colour on the shaded side. Then I carry on with the rigger, pressing hard at first to get the thickness of the branches, gradually taking the pressure off, until I finally reach the twigs. These are indicated as a soft blurred tone by a very light touch of the dry hake. The trunk of a tree in the middle distance would merely need a touch of dark on one side to stop it looking too flat, whilst a small distant tree would only need a line for its trunk.

Let's look at those same trees in summer. It's important to remember that it is still the same basic structure underneath the cloak of foliage as it was in winter. This seems like stating the obvious, until you've seen as many students' trees as I have! First you must resolve to simpliify the tree that you see in front of you. It's no good at all attempting to spatter your winter tree with thousands of tiny individual leaves to make it look like a summmer one, although I've seen that attempted many times. You should paint the foliage as several large masses of leaves. These should be varied in size and interesting in shape with rough edges, but each should have three dimensions. Some should overlap each other, but also have gaps in between them

BELOW
*Typical winter and summer trees, showing their basic overall structures. Give your winter tree a strong framework to hang the twigs on, remembering it's got to support them in a high wind. In your summer trees, restrict most of the branches to the sky-holes – don't put them on the outside of the foliage!*

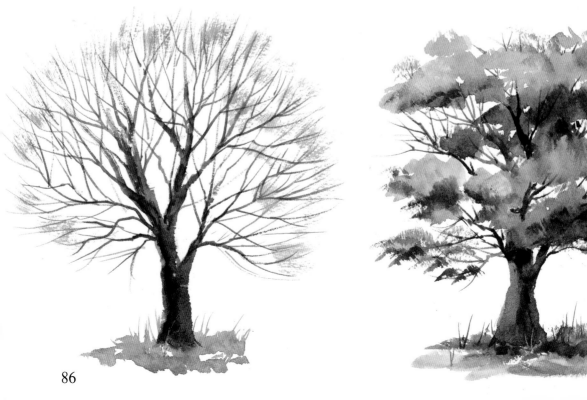

86

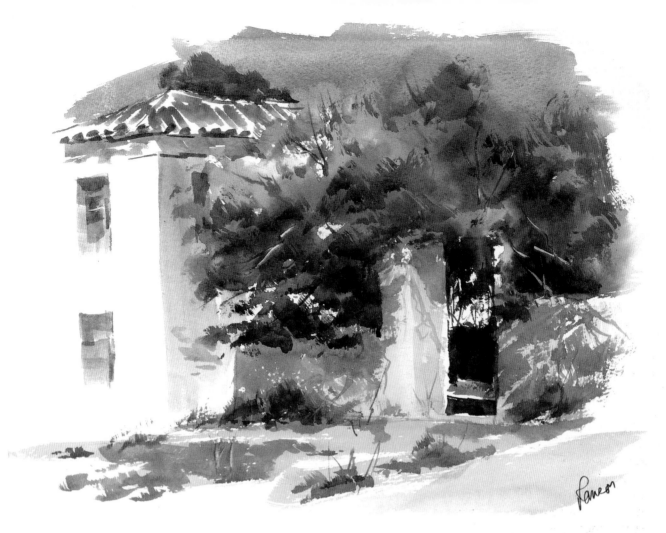

ABOVE
*This was a demo painting done on the Greek island of Spetses. I first found a spot where my 'flock' would be in the shade, then painted what was in front of me. I felt the warm dappled shadows falling on the white walls made this picture worthwhile. The strong dark greens, too, were exciting against the whiteness.*

to form important sky holes. In these sky holes you should show all your branches and twigs. Don't, as so often happens, paint them on top of the masses. They should be like trains going in and out of tunnels, and your viewer should be able to follow the structures as they re-appear. Overall, these leaf masses should combine together with the holes to form an interesting shape, which is the final silhouette of the tree itself.

If you can grasp the fact that foliage forms these simple separate masses, you'll be able to get away from this 'leaf painting', which besets so many students. You don't need any of this detail. These basic masses, plus five or six sky holes, can establish a tree much better.

Now to the colour of trees. Tree trunks are not necessarily brown, but come in various tones of grey through to green and sienna, frequently with all these greyish colours appearing on a single tree. The foliage, too, is not all a single green and is very seldom a bright green. You should look for blue/greens, yellow/greens and red/greens. Compare the greens of one tree with another, and you'll find it easy to recognise a great difference. They do, of course, vary with the seasons. The spring tree is probably a blend of yellow and yellow-green, whilst a mid-summer tree might be yellow/green on the sunny side, and olive or blue/green in the shadows. In the autumn, the foliage could be a blend of yellow, yellow/red, brown and even yellow/green.

The direction of your light source will make a big difference

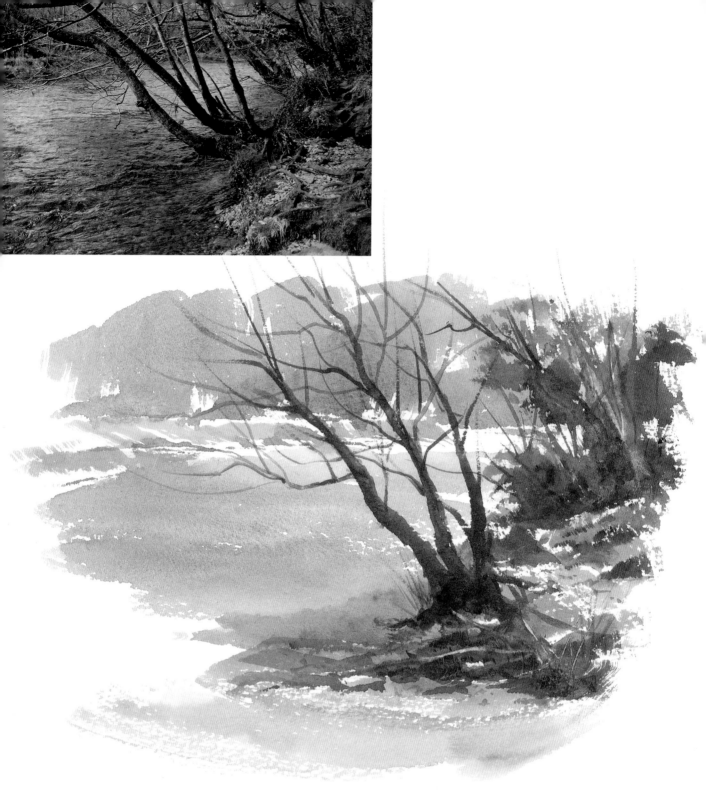

to your tree and each of your individual leaf masses will be moulded by its own shadows. The top mass will usually be the lightest, as it is facing the sun without interruption, while some of the lower masses will be shaded by those above.

Don't try to paint a large tree by filling your whole picture with it from top to bottom. If you really want to paint a large one, show only a small portion of it.

Although trees are the most important objects, bushes and shrubs are also part of the scene. They are usually dark, unless they are shrubs in bloom or flowering bushes, but their character

ABOVE
*This is a simple autumn scene on a Devon river. Notice how the distant autumn colours become almost mauve. I made them by mixing Light Red and Ultramarine fairly weak and adding a touch of Raw Sienna at intervals to vary the shade.*

is quite different from trees, even young trees. The branches of a bush begin very near the ground, so don't paint them to look like miniature trees.

To conclude this chapter, here are the most common faults which occur when painting trees. They may not be very constructive, but you will probably recognise a few of your own faults and hopefully be able to eliminate them.

First, the greens. They're usually far too bland and monotonous, with no variety in them, and, of course, this in turn produces a flat picture with no depth to it.

There's nearly always too much 'leaf painting', with no feeling of solid structure. I hope the information on page 86 will eliminate this.

One of the most common faults is painting branches on top, or on the outside of foliage, rather than leaving them merely in the sky holes where they should be.

One sees too many round 'lolly-pop' trees with no interesting contours. The edges of a tree shouldn't look like cardboard cut-outs. A rough, almost dry brush edge is so much better for indicating leaves.

Students often leave large white spaces in a sky to put their trees on later. Forget about this, paint the sky all over, then when you're finally ready to put in the trees you'll be able to see the sky through the sky holes rather than white paper.

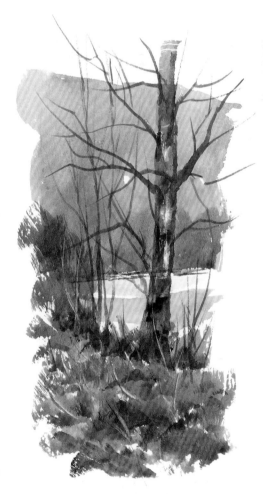

Winter trees, too, are often very badly painted, because the student hasn't learned to handle the rigger properly. Their branches don't always taper, and may even become thicker as they rise, which would never happen in real life. Because of the lack of confidence in brush control, so many trunks have 'whiskers' or perhaps just a few tapered branches, with no indication of twigs at all. This weakness, and it's very common, can ruin an otherwise good painting. The poor starved things look as if they've come through an awful holocaust. You must always indicate a strength of structure, to hold the tree and its weight of foliage up in a high wind. I'm always telling students off for painting incredibly tall twigs which look like hose-pipes.

As you will now realise, a little more thought and care is needed with your trees and foliage. You can't avoid them in most landscapes, and they can make such a difference to the professional look of your paintings if they're put in with confidence and knowledge. Let me repeat, as a watercolour artist, one can only really hope to give a sensitive impression of a tree or mass of trees in a landscape, not a photographic likeness of foliage by trying to put in every twig or leaf.

# Flowers
# with freedom

The most satisfactory lighting for a flower arrangement, with the source of light at about '10 o'clock' or '2 o'clock'.

I don't consider myself to be a flower person, though having said that, I was once asked to demonstrate watercolour to a convention of hundreds of lady flower arrangers! I'm pleased to say that many of my audience that day became enthusiastic watercolour artists afterwards.

So many students have said, 'Can you adapt your big brush approach to flowers?' If your aim is to produce meticulous botanical paintings the answer, of course, is, 'No', although I greatly admire some of these, which have been lovingly and painstakingly painted, but they need small brushes and infinite patience. However, if you can enjoy the thought of flowers in terms of form, pattern and colour, then it's a definite, 'Yes'. I must admit, I certainly don't know the names of many of the flowers I paint, but then the purpose of this chapter is not to teach you about flowers, anyway, but to try and help you to see and paint them in a simple way.

As with landscapes and buildings, my feeling is that you should consider a flower arrangement as an overall design on your paper. See it in terms of large forms, looking for the essentials and rejecting the unimportant, non-critical details. The flower paintings I see from my students show that many of them seem to get so carried away with the task of depicting the individual flowers correctly that the overall effect and pattern is not even thought about. The resulting painting, though delicately done, is scattered, disjointed and flat because they don't make enough use of light and shade.

It's often effective to make use of a dramatic shadow as part of the composition.

Before we even start to paint we should consider very carefully the ways of setting up the flowers themselves. This is a very important part of your creative progress and, whilst no one really tell you how to arrange your own set-up, I can, at least, give you some guidance about the commonsense 'do's' and 'don'ts'.

First, selecting your arrangements. Flowers, of course, come in an enormous range of colours, but if you try to mix them at random the result will probably be a bit of a hotchpotch. With wild flowers, of course, anything goes, and they'll also mix beautifully with weeds and grasses. But with a more formal arrangement, you'll need more harmony of colour. Roses in various shades of pink might look great, but to put a yellow rose amongst a whole bunch of red ones might look rather incongruous. There's no real hard and fast rule about all this, just trust your own good taste.

Match your containers to your flowers; a jam-jar may be ideal for a bunch of wild flowers, but not for a dozen formal roses.

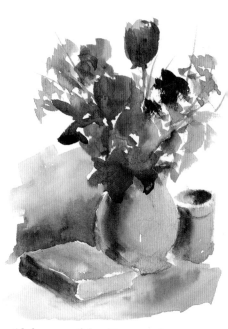

Make some of the objects overlap to avoid the arrangement looking disjointed.

90

Primroses wouldn't look right in a tall vase, but might look great in a champagne glass. Tall, elegant chrysanthemums would look silly in a wide, low bowl; they need an appropriate tall container. For freshly picked flowers, a basket is ideal, but for formal arrangements choose something like an elegant silver bowl. Mind you, all sorts of things can be pressed into service, such as an old coffee pot or a wine bottle, or even an old bucket, if it's appropriate to the flower arrangement. Don't place a multicoloured bunch of flowers in a very ornate vase or bowl, otherwise each set of colours will clash with the other.

BELOW
*A simple painting of roses, giving just a bare impression of the petals. I find the quicker I do this sort of thing, the better it turns out!*

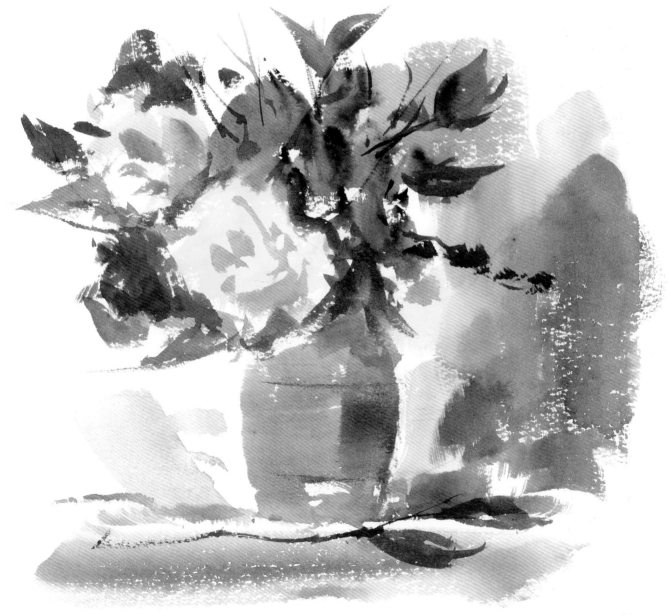

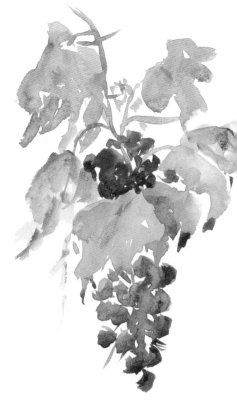

Of course, you can add one or two other props to go with your flowers and container. A piece of driftwood, fruit or even a glass of wine, will give you the opportunity of producing interesting textural differences, but beware of overcrowding your picture. Don't put them all in a straight line but make sure that at least some of the objects overlap. Put some in front or behind the container. Lots of separate pieces scattered about will just look disjointed. The objects, too, should be appropriate to each other, at least looking as if they have some reason for being in the same picture. If you're painting potted plants, they'll probably look most natural in their original, simple earthenware pots.

When you're arranging your flowers, try to avoid getting them perfectly balanced; this tends to make them rather boring. On the other hand, if you use too much weight on one side, they'll look as if they're about to topple over. Just try to make them look natural. You might add a few leaves and ferns to give a more uneven profile to the arrangement. In a low bowl let a few flowers or leaves hang over the rim, or even leave one or two on the table at the side of the bowl.

ABOVE AND BELOW
*Sketches of a vine and a lily done very quickly with the no. 20 round brush.*

Lighting is important too. If you set up a vase or basket of flowers in direct sunlight where all the flowers are hit by the light, they may look bright but rather flat, and if you put them all in the shade they'll simply look dull. The best way is to place them so that some of the flowers are lit and some of them are in shade. The whole effect will then be richer and more dramatic. You can get the same effect indoors using artificial light. Here you can make the flowers look even more brilliant, because the shadows will probably be darker and have even more contrast than in the sunlight. Perhaps one of the simplest and most practical ways is to light your arrangement from slightly above and in front of the upper left- or right-hand corner. This lights about two-thirds of the flowers on the top and side, leaving the bottom of each flower and about one third of the entire set-up in the shade. Unlike landscapes where you have to take what you can get, with flower painting you can control your shadows to your own taste. You can make them as dramatic or subtle as you want, just by moving your light source.

Once you feel your set-up is basically satisfactory, look through a small cardboard viewfinder, moving it backwards and forwards, trying different angles and directions. Be very critical and ask yourself if the shape hangs together well as a whole.

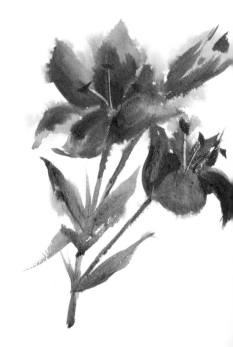

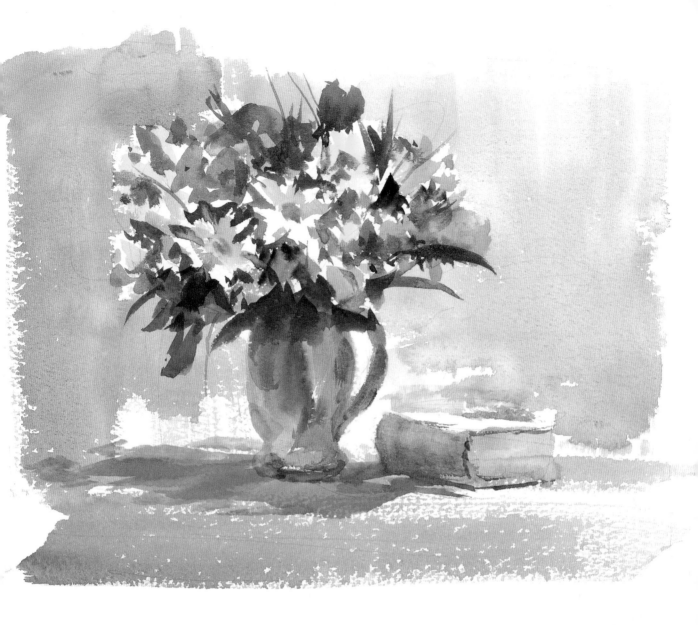

ABOVE
*A bunch of mixed flowers in a jug. I've held the background back to pale subtle greys to emphasise the bright colour of the flowers.*

After all the preliminaries, let's get down to the actual painting. Flowers give you practically unlimited opportunities for using all the techniques of watercolour to your heart's content, without even the normal restriction of landscape. You can experiment and be as wild and uninhibited as you like. After all, it's only paper and if you're going to ruin it you might as well have a jolly good time doing it!

Seriously, though, try to think of the flower arrangement in front of you almost as an abstract pattern. Screw your eyes up tightly to cut out most of the detail and then let fly! You might try wetting your paper first, dropping in areas of colour and letting them blend. Then, as the paper gradually dries, start indicating hard edges to explain such things as the edge of a petal or a leaf. Counterchange is just as important when doing a flower painting as it is in a landscape and you've got to be constantly thinking of ways to throw up light flowers, perhaps by painting a dark patch of foliage behind, or putting a darker flower against a light background.

Don't neglect shadows either; they can be a very important part of your whole composition. All that I've said about shadows in Chapter 13 apply equally to flower painting. There are local

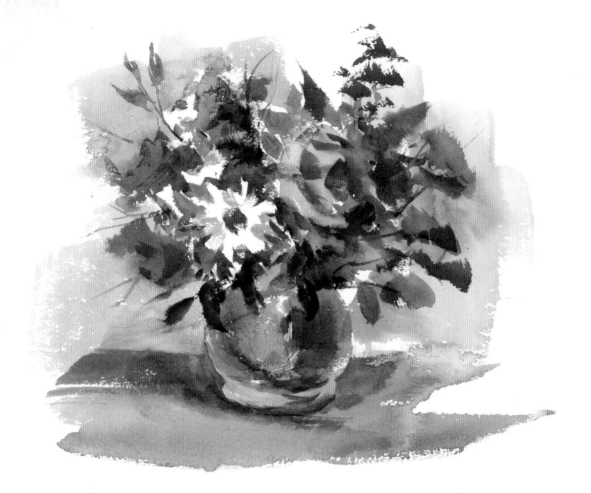

shadows, which give shape to each flower, and cast shadows that are thrown by one flower on an adjacent flower or foliage, helping to throw it into relief. The arrangement as a whole is also shaped by a local shadow and a cast shadow may then fall across a table and up a wall, becoming part of the whole design.

Be very careful not to make your shadows too dark or opaque. If they're too dark they'll look like holes in your paper and if they're opaque you'll lose that essential freshness and transparency. Bright, colourful, hard-edged blossoms may be counterbalanced by warm, soft-edged shadows. You see, therefore, that shadows are an integral and essential part of the painting.

Constantly compare colours and tones against each other.

ABOVE
*A bowl of mixed flowers from the garden. Notice how the daisy is indicated by painting a dark negative shape behind it.*

LEFT
*Chrysanthemum. Here I dampened the paper first before putting in some of the strokes, and added more after drying the paper.*

For example, is that red rose darker or lighter than the blue cornflower next to it?

Although I find most of my flower paintings can be done with the hake and the rigger, I must admit for this particular subject an ordinary pointed brush might need to be used too, but not a small one which would encourage you to fiddle.

I've just come across a superb brush that might have been made exclusively for free flower painting. It's a size 20 round Prolene brush by Pro Arte, which comes to a needle-sharp point yet costs only a fraction of the cost of a sable to buy. I must admit that when I first used it, it gave me a tremendous sense of excitement. Its very flexibility opens up new possibilities, yet it is not in the least 'fiddly'. By using different amounts of pressure, with practice you can achieve amazing results with it. Begin by painting a few individual flowers, first on dry paper and then on a slightly damp surface. Experiment by painting in the shape of the flower in one wash and dropping in almost neat paint while the first wash is still wet. Then, after leaving the flower to dry, just suggest a few sharp details—but not too many! I often have a hairdryer in one hand and the brush in the other when I'm really excited and can't wait for the paint to dry by itself.

You might also need one or two more colours than I, in my restrictive way, have allowed you previously. Cadmium Red, Cadmium Orange and Cerulean Blue may help you to get some of the brighter flower colours.

I've shown you here a few examples of loose flower paintings in watercolour but they're only an introduction to the possibilities; we've only scratched the surface. This is an area where you can really express your own personality. Don't get too uptight and worried about your flowers being botanically correct, just go ahead and enjoy yourself. I can recommend a very good book on the subject, *Flower Painting in Watercolour*, by Charles Reid. An occasional dip into this always fills me with the desire to have a go.

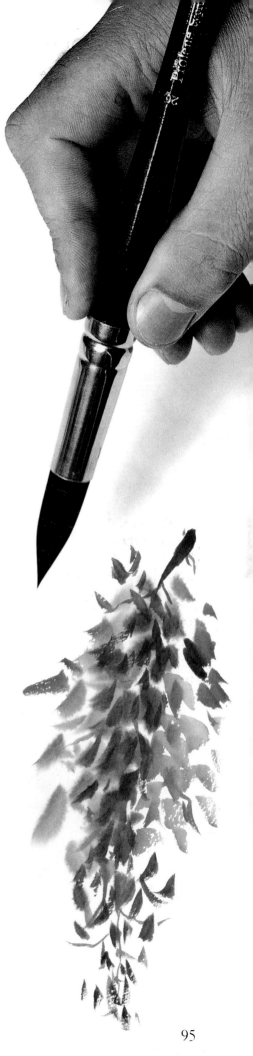

TOP
*The size 20 Pro Arte brush with its superb point.*

RIGHT
*Wistaria. The paper was slightly dampened first, so some of the blossoms are soft. Harder, darker blossoms were added after the paper dried.*

# Being bold with buildings

This is a chapter about painting buildings in a free, economical way. I'm not going to start by talking about the lines of perspective and vanishing points; I've done that in my previous books and I'm assuming that you know about that sort of thing anyway.

I was talking to one of my faithful and regular students only this morning, telling her I was just about to start on buildings, and she said, like many others have said before her, 'I can draw buildings reasonably well with no really obvious faults, but when I come to paint them, I tighten up and find everything becomes stiff and overworked. Even though I'm quite free and loose about other things like trees and rivers – I certainly need help with my buildings'—so here goes!

The trouble is that most of us don't have the confidence to believe we can symbolise a building in the same way we have already learnt to symbolise trees or rivers. We simply can't accept that our viewers will understand a building which does not have lots of detail, so we try to explain every brick and window pane, using smaller and smaller brushes to do it. To some extent we suffer this same nervousness when it comes to putting figures into pictures—the figure and the background often seem to have been painted by two different people.

With buildings, you must get your basic drawing right; there's no argument about that at all. If your roof line or your doors are at the wrong angle, no amount of detailed work on top is ever going to make them look convincing. However, if the construction is fairly sound, and the overall light and shade has been worked out properly, your viewers will then be quite happy to do a lot of work themselves, cheerfully accepting one or two stones on an otherwise flat wall to indicate texture, even if it's in the foreground. As the buildings recede, the odd window left out won't worry them either.

When I'm in Greece, running my painting courses, I often indicate a whole village with a few angled marks for roofs, the odd dark cypress to pick out the profile of a house and finish off with a few marks for windows, and everybody seems to believe it—it's all part of the fun. On the other hand, some of my students, painting the same scene, spend hours doggedly and patiently trying to draw every house and window and are then disappointed at the end because they've lost the essential quality of freshness and light. They soon get over this though, and 'loosen-up' considerably during the second week of the holiday.

By far the commonest weakness in students' paintings of buildings is a monotonous all-over flatness, with very little

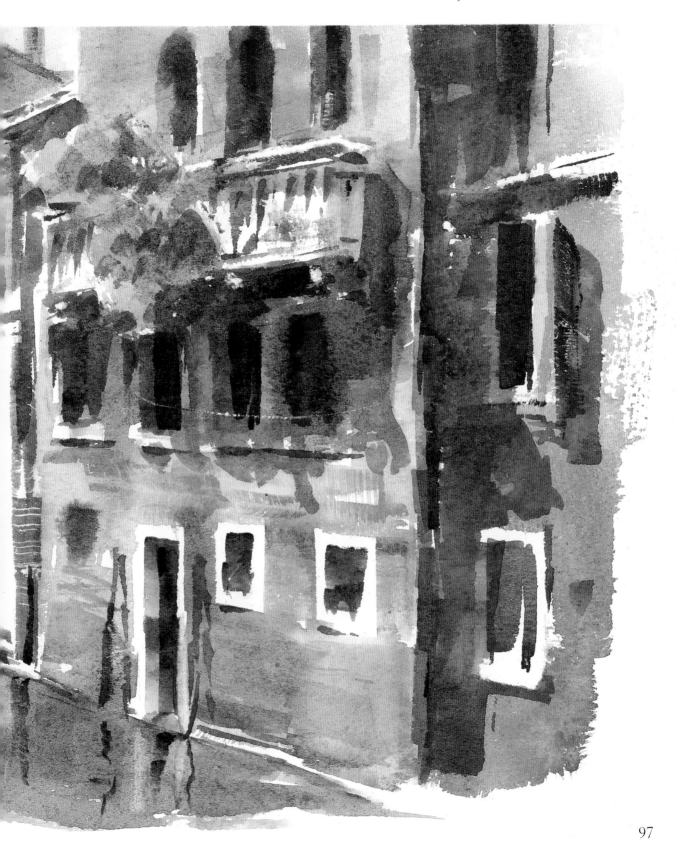

97

change of tone, whether the side of a house is facing the sun or is in the shadow. There are often very few descriptive darks, and roofs merge tamely into the trees behind them.

If you're going to portray buildings in a more simple and direct way, you have to learn ways of dramatising the features, continually exploiting every shadow to describe the various surfaces and planes it falls over. Make up for the lack of detail by being more explicit and forceful, informing your viewer instantly about the various shapes and angles of the building.

Just as I'm, now, searching my mind for good, short descriptive words to put over these ideas quickly whilst at the same time trying to hold your interest, you have to simplify, organise and exaggerate the tonal values to make them more 'fast reading'.

*This shows how you can simplify a scene dramatically. Here is a street in a Greek village, making maximum use of white paper and counterchange yet still retaining the essential atmosphere of the original scene.*

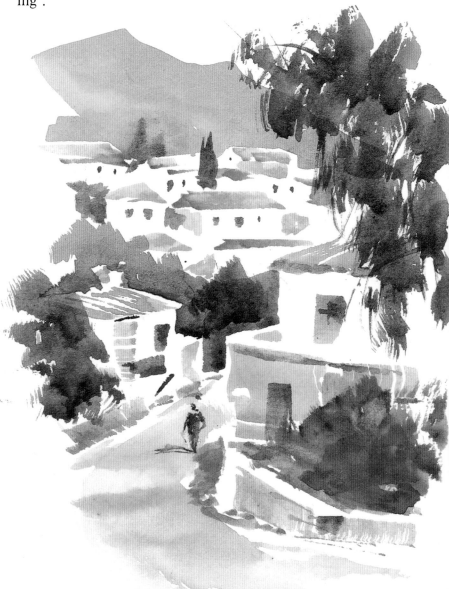

Counterchange is again vital in this process; in fact, if I can only convince you how important it is in painting buildings, this chapter will have been thoroughly worthwhile in itself. The actual overall profile of a building is important and should contrast in value with whatever is behind it—a light sunlit building against a dark tree—whereas a building in shadow could be dramatised against a light sky; thus some counterchange should carry on throughout the building by the continuous use of light against dark and dark against light.

Another giveaway in students' work on buildings is the monotony of colour on their walls. They settle for a certain mix for a particular surface, and they just paint it on all over like a coat of emulsion. In fact, every self-respecting wall has lots of varying colours on it in different areas. What I normally do is to lay an all-over mix in a predominant colour but as I proceed across the surface, I put my brush into other colours in turn, to augment it, as it were. To the original colour I might add a touch of blue at one point, a touch of brown in another, and even Raw Sienna in another. The result is much more satisfactory and interesting.

It's terribly important that you think in terms of larger masses and areas than you have before. As I've said elsewhere in this book, students often seem obsessed with slowly building up walls stone by stone, which finish up looking childish and 'bitty'. Consider the whole wall first in the varied colours as we've described and then, taking things a stage further, add the minimum of texture once the first wash is dry.

Another thing which is often done is to paint the dark and light sides of a building separately, trying to knit them together at the corners, rather like a patchwork quilt. It's much better

to paint all the walls together and add another dark wash to the shadow side after the first one has dried.

If you have a look at some of the illustrations in this chapter, you'll see how important the cast shadows are in describing the various surfaces on buildings. Architectural detail can often be suggested easily and quickly merely by indicating the shadows they cast. Do try to avoid muddy opaque shadows and allow the original colour of the walls to show through—more of this in the next chapter.

Now let's think about the brushes. The sharpness and crispness one can get with the 1in brush is ideal for nearly all the details such as doors, steps, windows, and for adding the stone texture. Again I've tried to show this in my illustrations. Even balcony railings can be indicated by laying the edge of the brush lightly on the paper. The hake, whilst a little too crude for showing sharp details, is very useful for covering large areas of wall and large cast shadows.

THIS PAGE
*A few quick sketches done mostly with the 1in flat brush.*

OPPOSITE
*A typical village scene on the Isle of Spetses done as a twenty-minute demo.*

# Seeing shadows

*Form shadow.*

*Cast shadow.*

*Combined form and cast shadows.*

*How a cast shadow follows the contours of objects on which it falls.*

Shadows can be a great help and friend to an artist. Once they're understood, they can be used to great advantage. They are a vital part of the landscape and, if allowed, will describe the forms throughout a picture. Shadow patterns, in themselves, can often enliven a whole painting, adding interest and excitement. Many times, I've been working on a watercolour that seemed to be going wrong (you must have felt that disappointed feeling at the pit of your stomach), and at the very last moment I've added my shadows and the whole painting has been transformed in seconds.

The trouble is that students so often badly neglect shadows. They add a few aimless, dark grey streaks across a road which look like opaque strips of polythene, or else they put an odd patch of shadow on a plain bit of ground to break it up a bit, disregarding the fact that there's nothing actually there to cause it.

Like many of the other aspects of watercolour discussed so far, shadows have to be thought out logically and carefully, even before you mix the colours. This may seem obvious, but you must then firmly decide where the light is coming from. After making sure all the surfaces you are going to work on are dry, take a deep breath, and put the shadows in quickly and decisively. Once they're down, don't muck about with them, or try to alter them; it's important that they're transparent, with the underlying local colour of the various surfaces showing through.

Shadows really fall into two categories. The first is called the form shadow, which shows on every part of an object facing away from the light source. It's a vital factor in giving form and substance to a shape, whether it be a jug, a face or a house. The second is the cast shadow, and to me, even more interesting, though it needs a bit more study and understanding if you're really going to make it work for you. Its shape is formed by two things—the object that causes it, by interrupting the light, and the shape of the surface it's falling on. It's this last fact that can really be exploited by the artist, as it conveys instantly to the viewer what the surface is and how it undulates. For instance, the cast shadow of a pole might fall over a cart track, showing all its ruts, then over grass, where it changes colour merely because of the underlying green showing through, and finally changes direction completely as it goes up and over a wall.

Another way of using a cast shadow creatively is to throw a shadow across a foreground, as Rowland Hilder often does, imagining that the shadow has been cast by some large object

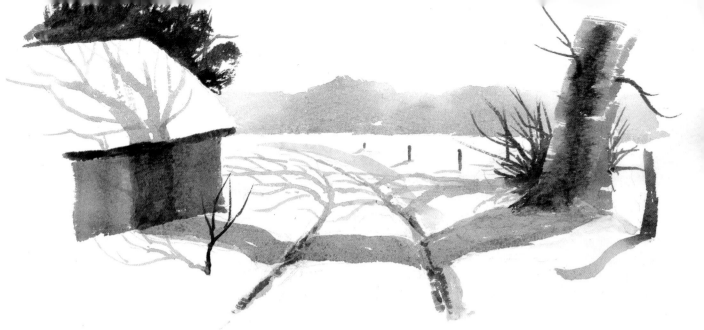

outside the picture itself, perhaps a tree or a building. This device can strengthen a picture by giving it a solid base, or perhaps by providing a strong contrast to a sunlit object in the mid distance.

The position of the sun, also, controls the length of a shadow, so a picture painted in the early morning or early evening can be often more dramatic and exciting because of the longer, and therefore more descriptive, shadow.

Students often grumble, when working on site, that the shadows keep moving. Apart from taking too long over their painting anyway, they're inclined to add the shadows progressively as they work over the picture, and finish up trying to alter some of them at the end, to make them all consistent. This makes them muddy and opaque, not at all the way you want your shadows to look.

The secret, of course, is not to put any shadows in until the picture is almost complete, then study the scene carefully, and put them all in together. Don't forget to put them *all* in. I've often seen students add an imaginary figure to a painting, but completely forgetting that it, too, casts a shadow.

Now to the shadow colour itself. I'm often asked what to mix for shadows. One thing it shouldn't be is a muddy opaque grey or black! This will kill your picture stone dead instantly. My own preference for most pictures is a mixture of Ultramarine and Light Red—just halfway between the two gives you a warm mauve/grey. The next thing is to get the consistency right. Too weak, and you'll find you're tempted to put on a fatal second coat, which will make it look overworked. Too thick, and it will cover up the underlying colours already there, and it's these various colours showing through which lend purity and liveliness to a watercolour. In snow scenes, the shadows are even more important, as they're often the only thing to indicate the undulating surface of the snow. If it's a clear day, I usually use a weak blue which takes its colour directly from above.

The colour of form shadows is often determined by things that surround the object. For instance, the shadow colour on a girl's face would depend on the colour of her dress, which would bounce from the dress on to her skin. In the same way,

*The above illustration shows how important cast shadows can be to show the profile of the ground they fall over. Notice how they travel up and down over the ruts, up banks and over nearby objects.*

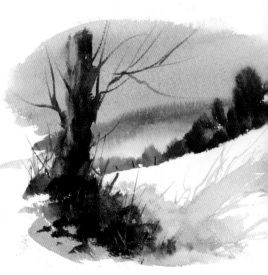

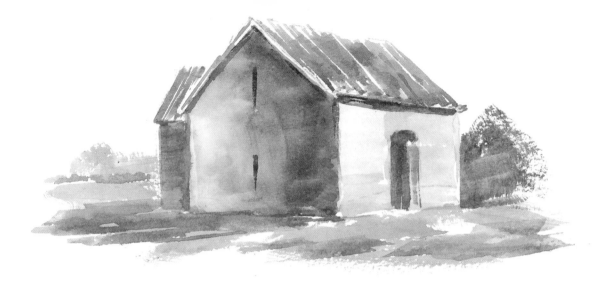

the shadow colour on the side of a house would be governed by such things as a green tree next to it. I know this sounds very subtle, but you can see it all if you really look for it.

Taking this a stage further, when you have a building showing two sides, one facing the light and the other in shade, the darkest part of the shadow side should always be shown right at the edge where it turns out of the light. From that point, your shadow should become gradually lighter as the building recedes. This, again, occurs because of the light bouncing off the ground.

Although this, too, is very subtle and almost indistinguishable in real life, as an artist you should exploit and exaggerate it. It will make your shadows much more interesting and dramatic.

Very much the same sort of thing happens when round shapes like balls or cylinders are lit from one side. Although, being round, the contrast is not quite so sharp, the darkest part of the shaded side is still just where it turns away from the light. From there onwards it lightens, again due to the bouncing light. If you substitute a sunlit tree trunk for the cylinder and a flower bowl for the ball, you'll begin to see how you too can exploit this in your paintings.

Perhaps this has convinced you that shadows are more than formless, dull grey patches. If you think of shadows generally as strips of transparent, smoke-tinted acetate, laid over parts of your painting, perhaps then you won't be inclined to paint solid opaque shadows again — I hope!

ABOVE
*In this illustration notice how the darkest part of the shadow is just at the point where it turns out of the light – from there on it becomes lighter.*

BELOW LEFT
*A flower picture showing the position of the darkest part of the shadow. This is called the 'core'.*

BELOW
*This also happens on a sunlit tree trunk, where light reflecting from the ground produces the same effect.*

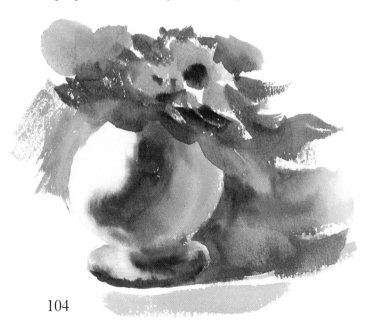

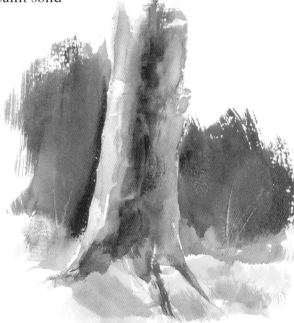

# Putting it all into practice

So many of the students have told me that one of their main problems is knowing what to leave out—separating the essential from the trivial. So in this section I'm going to take you through a whole collection of paintings showing you the scene as I first saw it, often very cluttered, and the ways I've tried to get the essence of what was in front of me, rejecting a lot of what I thought was superfluous, simplifying what was left and re-arranging the tones to make the scene more instantly 'readable'.

The annoying thing is that it always looks so obvious when someone else has done the sorting out for you! So many beginners sit and slavishly copy their favourite artist's work stroke by stroke without even attempting to understand the thought processes that brought about the original work. They thus learn nothing worthwhile and are content to ride on the shoulders of another artist, accepting the praise of friends and relatives for a standard of work they couldn't possibly have achieved by themselves.

I've tried to include the whole process for each painting on one double-page spread so that you can study it without flipping the pages backwards and forwards (a thing I find most irritating myself!). I want to persuade you to study each spread in turn, and try and understand this mental process of distillation, as it were. I've resisted the temptation to fill lots of pages with wash by wash procedures—if you're like me yougo straight to the last one anyway.

I hope after you've been through this lot the penny will drop and you'll be able to apply what are really simple rules to your own paintings. I've even provided you with a few actual scenes at the end to get your teeth into as exercises, but remember, don't you dare copy them! First do your tonal sketches and don't be afraid to alter them drastically as you feel fit.

Although here, of course, we're working from photographs, my whole aim is that once you've accepted the idea, you should apply this same thought process when working out in the open, on site. Don't just copy nature—interpret it.

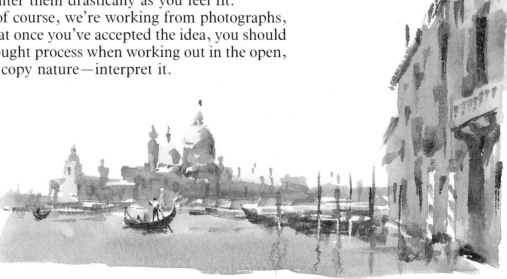

# DURHAM FROM THE RIVER

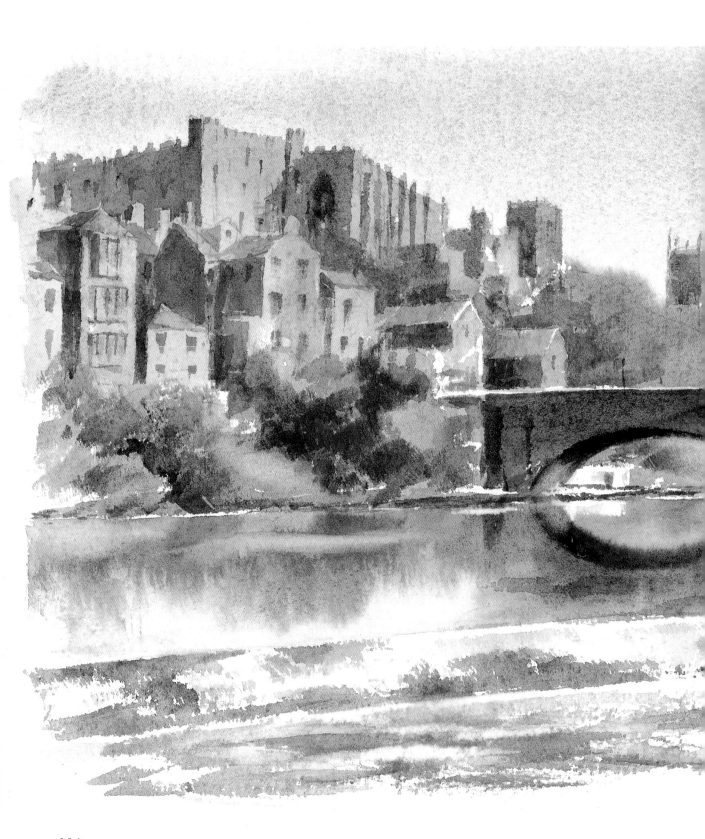

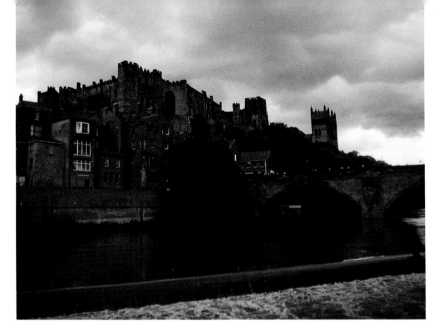

*This is not a good photograph – it's
taken on a very dull day and is too flat,
but I found the skyline and bridge
dramatic as a subject.*

I was asked to run a workshop in the lovely city of Durham. It
was my first visit and I found it full of exciting subjects. The
river itself winds right round the city. I've tried to simplify the
buildings as much as possible – they're put in with the 1in flat,
including the windows, for which I used the corner of the brush.
I've tried to bring out the profile of the roof-lines by counter-
changing them against the greenery. I've also lightened the far
distant trees to throw up the bridge. The river is very wet-into-
wet, with dry-brush for the weir.

*You can see what I've done here –
basically changed the lighting direction
to dramatise the bridge and bring out
the buildings. I've also lowered the
tone of the distant cathedral.*

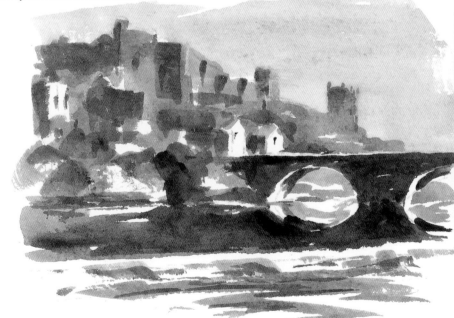

*Here the river runs across the beach and into the sea, but the foreground seems a bit weak with the river needing more contrast.*

# THE RIVER MOUTH AT CEIBWR

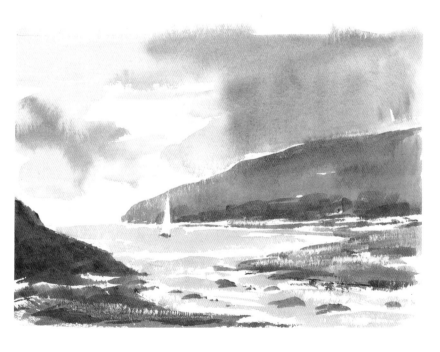

*In this tonal sketch I've made the river much more obvious, which in turn gives an entry into the picture, leading the eye to the little sailing dinghy.*

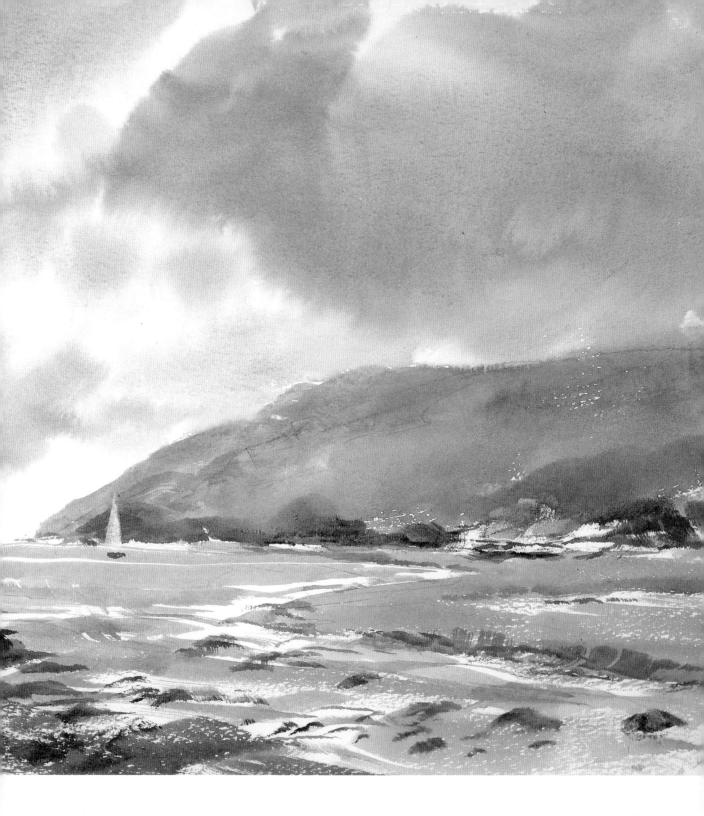

This is a little bay near Cardigan. I admit that this time I hadn't actually been there. It was taken from a student's photograph but it seemed a good opportunity to demonstrate how a fairly ordinary scene can be dramatised. The main interest, of course, was the river mouth and you can see from the tonal sketch how I've tried to emphasise it. In the finished painting I've used the direction of the brush strokes to give more movement. I enjoyed doing the sky, dropping a rich mixture of Paynes Grey and Alizarin on to a wet wash and tilting the painting up to make it move. I got the sailing boat out afterwards as shown on page 24.

*This was a 'natural' made interesting by the constrasting dark trees against the white snow and the strong transparent shadows.*

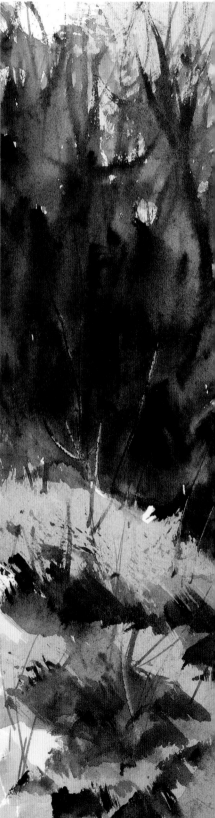

This is a local picture of the village of St Briavels. It had been snowing all night, and in the morning there was a clear sky and brilliant sunshine. I got my gum boots out and tramped through the thick snow looking for as many exciting compositions as I could find while the conditions lasted. I was pleased with the composition of this particular shot so I concentrated mainly on simplifying the rather fussy foreground, emphasising the top profile of the right-hand bank against the distant hillside and giving a more obvious entry into the picture. The shadows on snow are very important to show the forms, but to keep them transparent they have to be thought out carefully beforehand, and then put in very quickly and decisively. Don't go back and touch them up or they'll look overworked and muddy.

*I haven't needed to change the tonal sketch much but I've given a stronger direction to the lane by using imaginary cart tracks, and counterbalanced the left-hand trees with smaller bushes on the right. I added a figure and his dog.*

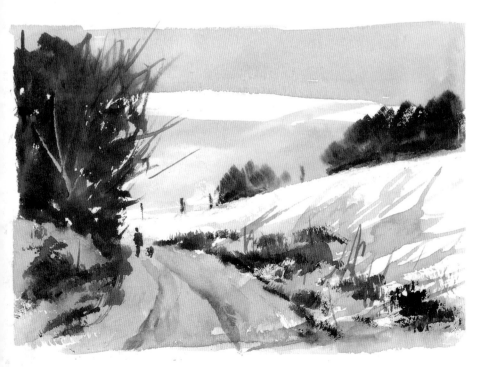

# THE LANE IN WINTER

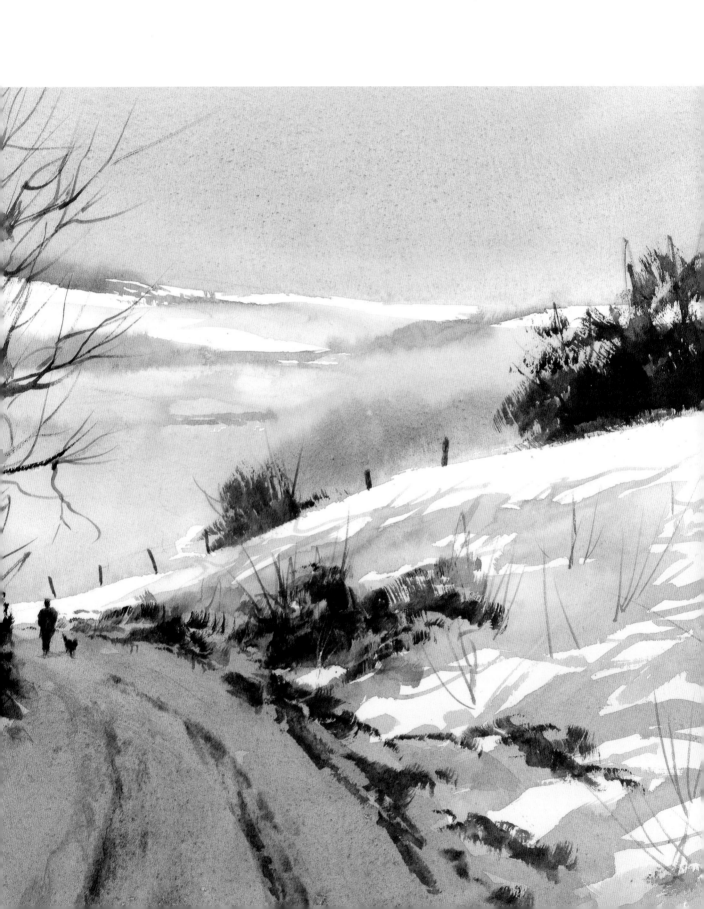

*The main trouble here is that the boat is too near the edge, and points out of the picture. Also, its tone is almost the same as the background behind it.*

When I'm in Maine running my workshops each year I take a day off to visit the magical island of Monhegan, which seems to be entirely populated by fishermen and artists. The atmosphere is incredible and has provided me with much material. This beach scene has attracted many artists, and various paintings of it can be seen in galleries all over the island. I've taken quite a lot of liberties with this particular scene, as you can see, moving things around and even changing the colour of the boat. The figure in the photograph can hardly be seen but I've emphasised him more in the painting. Notice too how I've worked and varied the colours of the huts, which in reality are a bit flat. I've also made more use of shadows, and eliminated some of the rubbish.

*I really enjoyed painting this tonal sketch itself. While doing it I decided to make the boat the main centre of interest by counterchanging it against the dark doorway.*

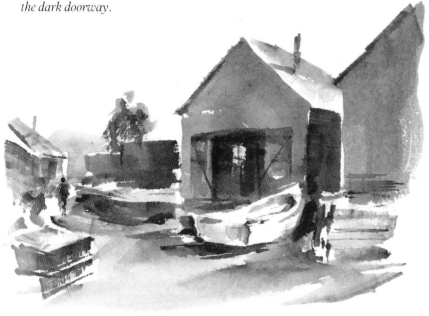

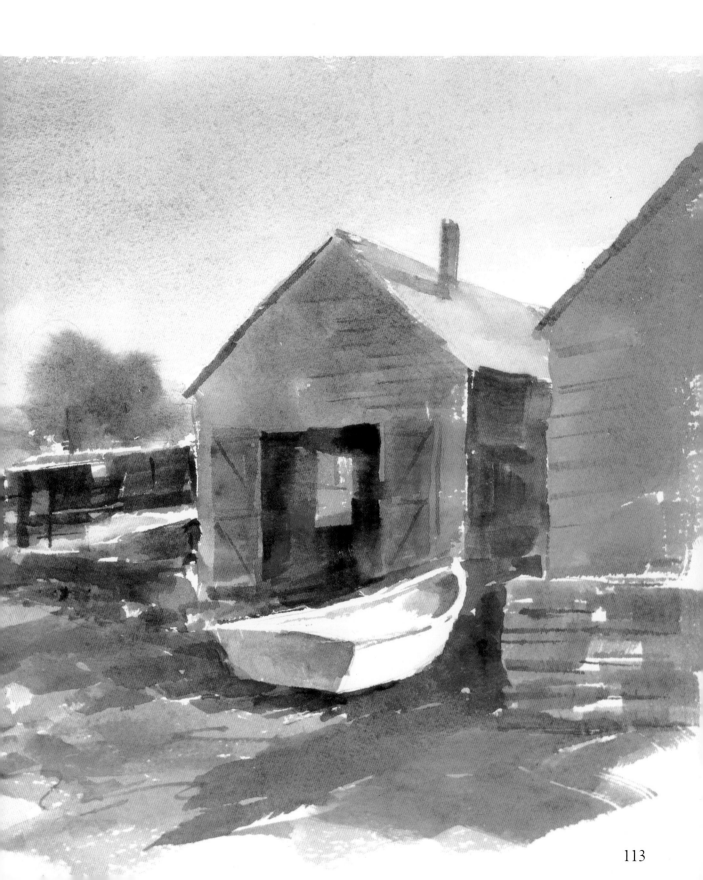

# THE MOSQUE AT BRUNEI

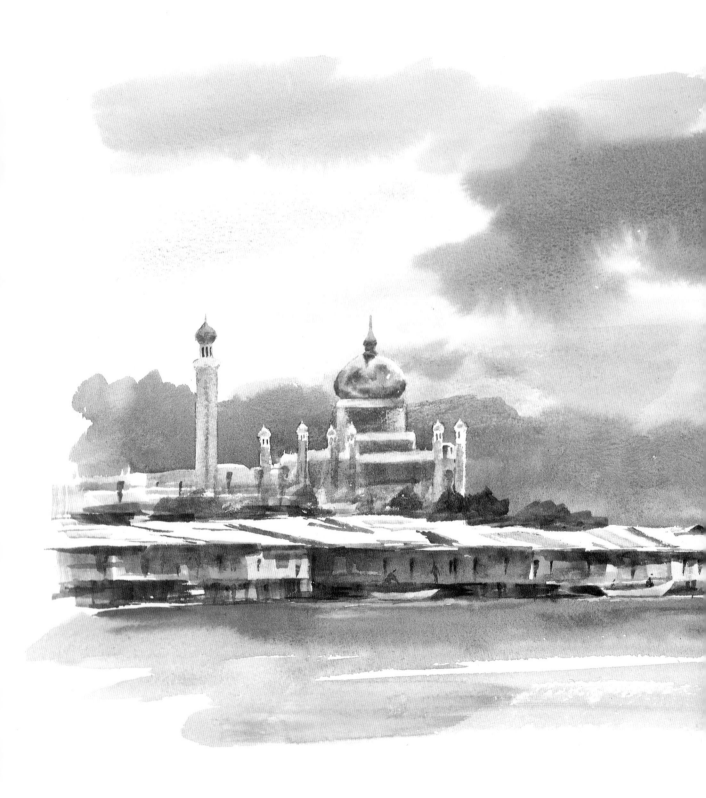

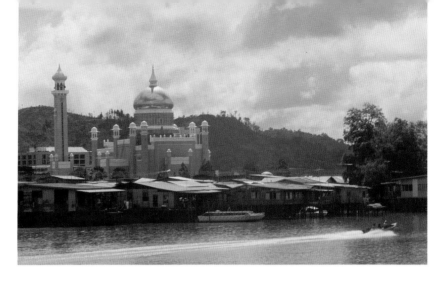

*The composition itself was a very satisfying one but the tones needed simplifying and organising.*

This was a really exciting trip. I was asked by the British Council to spend a few days in this fascinating monarchy on the tip of the island of Borneo, and show native Brunei artists some of my watercolour techniques.

It's a very rich country, but many of the population live over the water in their traditional houses with corrugated iron roofs. In this scene I loved the contrast of the ornate gold topped mosque surrounded by the houses and river, with the boats travelling at incredible speeds.

I liked the idea of doing it as a vignetted subject with a very loose wet-into-wet sky – you get a lot of rain there! I also, for once, used masking fluid on the mosque so that I could put in the distant hills freely and directly. Notice how I've put a bit more life into the houses themselves with a suggestion of activity going on.

*In this tonal sketch I've tried to counterchange the mosque against the background hills and make much more use of the light on the house roofs by unifying them into one complete area. Note the counterchange of the roofs on the right by the tree.*

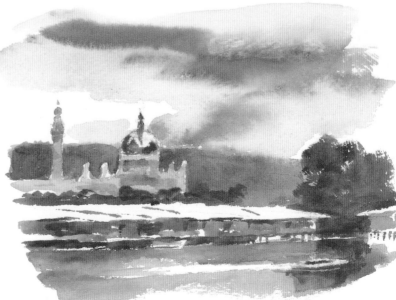

# SNOW OVER LOCH KATRINE

This was a scene I discovered while running a course in Scotland. It was in March and the snow had not yet melted on the mountains above the loch. It was a bitterly cold day and my wife sat in the car while I scrambled around the shore composing and taking pictures as fast as I could. In the finished painting I've simplified the background but have 'lit up' the ground on the other side of the loch. Notice how I've counterchanged the bracken and rocks against the dark foliage behind them. In a scene like this I feel these continual contrasts help to create interest – even the dark foreground grass against the light water.

*This was obviously a vertical subject, for a change, with plenty of depth to it from the foreground rocks to the distant snow-covered mountains.*

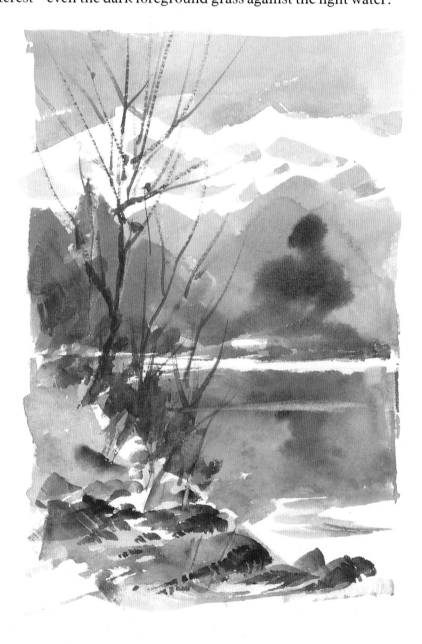

*The first thing I did in the tonal sketch was to darken the sky in order to bring out the profile of the mountains. I've also put a more pronounced curve to the rocks in the foreground to contrast with the water and lead the eye into the picture.*

116

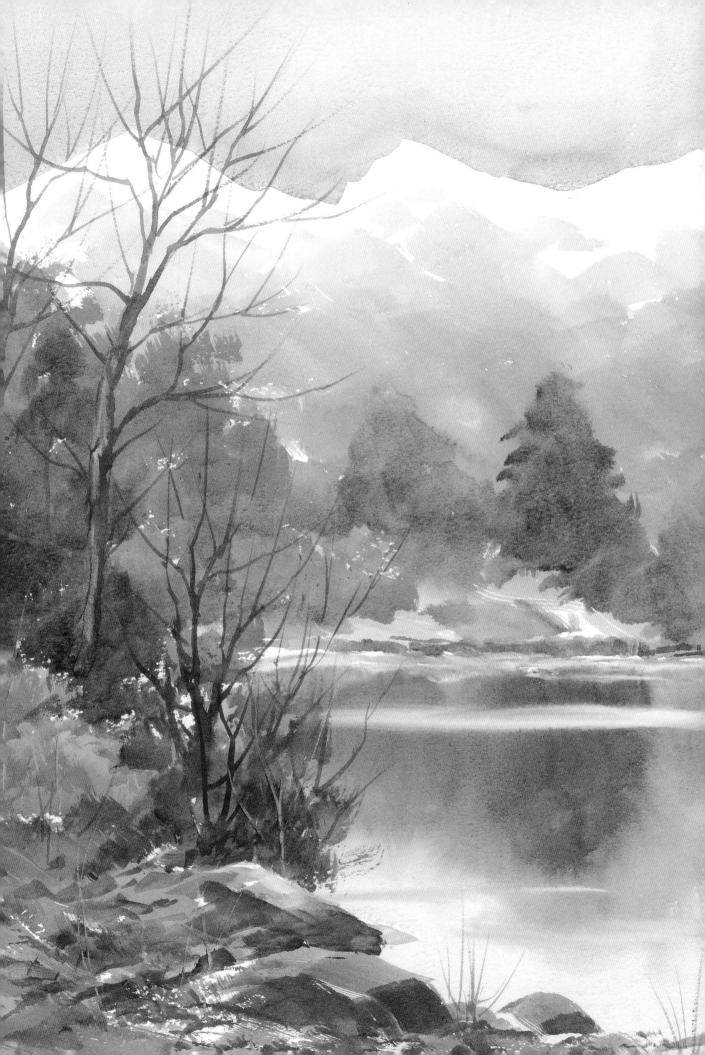

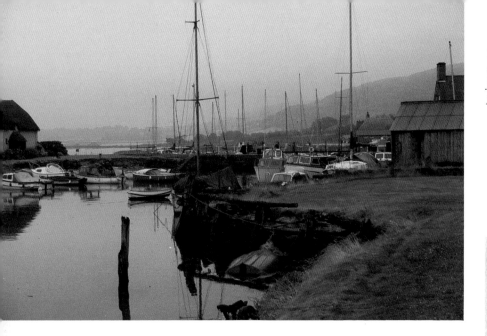

This is one of my favourite haunts and often my wife and I take the opportunity of some special occasion, like a wedding aniversary, to spend a night in the inn overlooking the delightful Somerset harbour. One can wander around this compact spot painting it from all angles, and the high and low tides provide completely different opportunities.

This particular picture was done for the *Artist's and Illustrator's Magazine*, and was photographed at various stages of completion. Perhaps the main change from the actual scene was the way I tried to light up the middle distance to contrast with the background hills, which themselves have been given more recession from right to left. I've also tried to make the sky a little more interesting without distracting attention from the main point of interest – the harbour.

*I felt the tones were too complex and I've tried to make a more straightforward pattern. I've darkened the house and hut on the right to provide some contrast with the hills behind, and simplified the end of the jetty.*

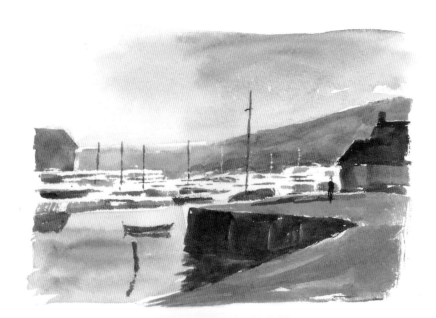

# THE HARBOUR AT PORLOCK WEIR

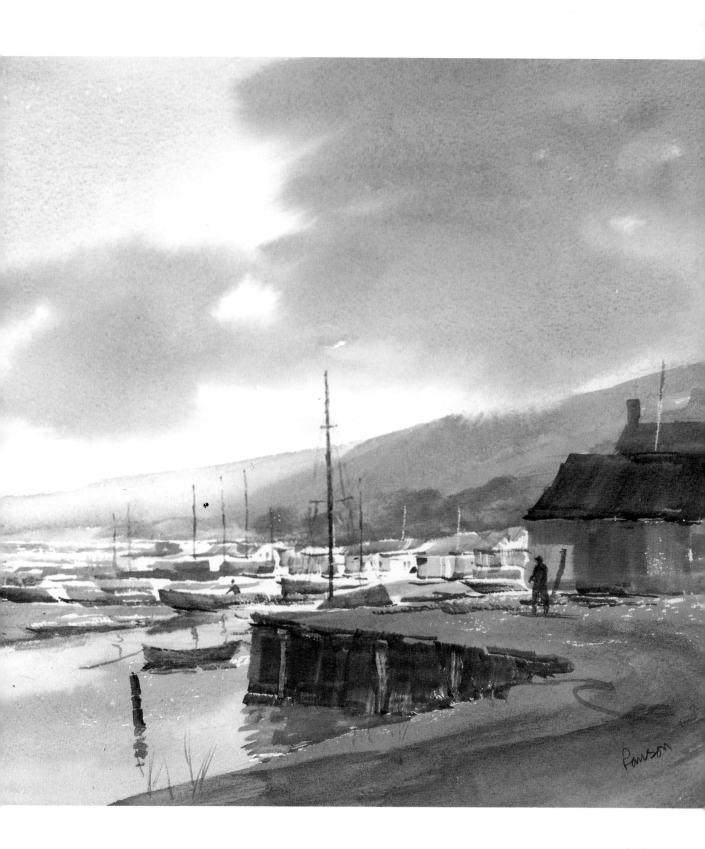

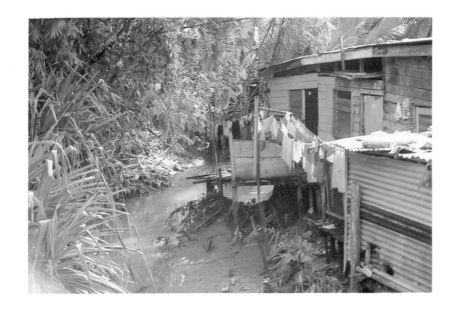

*This location was hardly conducive to watercolour painting on site as the flies and mosquitoes were only just outnumbered by the swarming children around me, but it was too good to miss.*

This is another scene I stumbled across on my last teaching trip to Brunei. It was a sort of shanty town, with the jungle coming right up to and overshadowing the corrugated iron and wooden dwellings. The living conditions look a bit rough but everyone was clean and happy, with fresh washing hanging everywhere. I felt the basic composition here was exciting, with lots of different texture. The jungle seemed to call for wet-into-wet treatment, contrasting with the hard sharp lines of the house and colourful washing.

The jungle has only been hinted at, especially in the distance. I've also lightened the river to provide more counterchange with the wooden supports of the hut, as I felt this was my main centre of interest. I've added a little more interest to the hut itself by varying the colour of the walls. I used the hake and rigger for the jungle and mainly the 1in flat for the building.

*In the tonal sketch I've tried to emphasis the profile of the house more against the background foliage.*

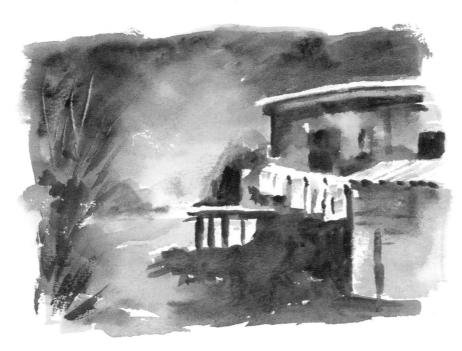

# JUNGLE HOME

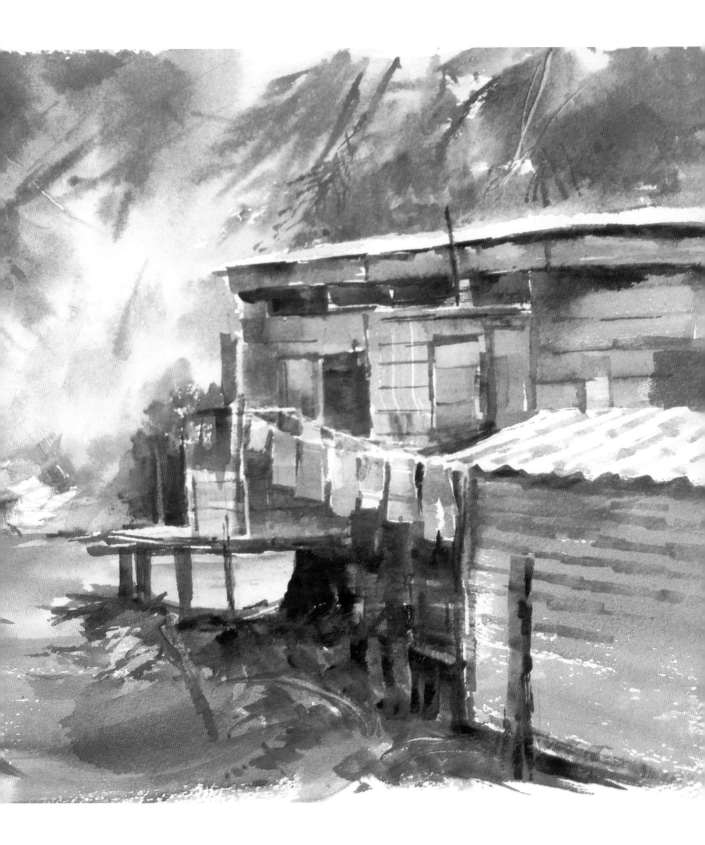

# AUTUMN ON LOCH LOMOND

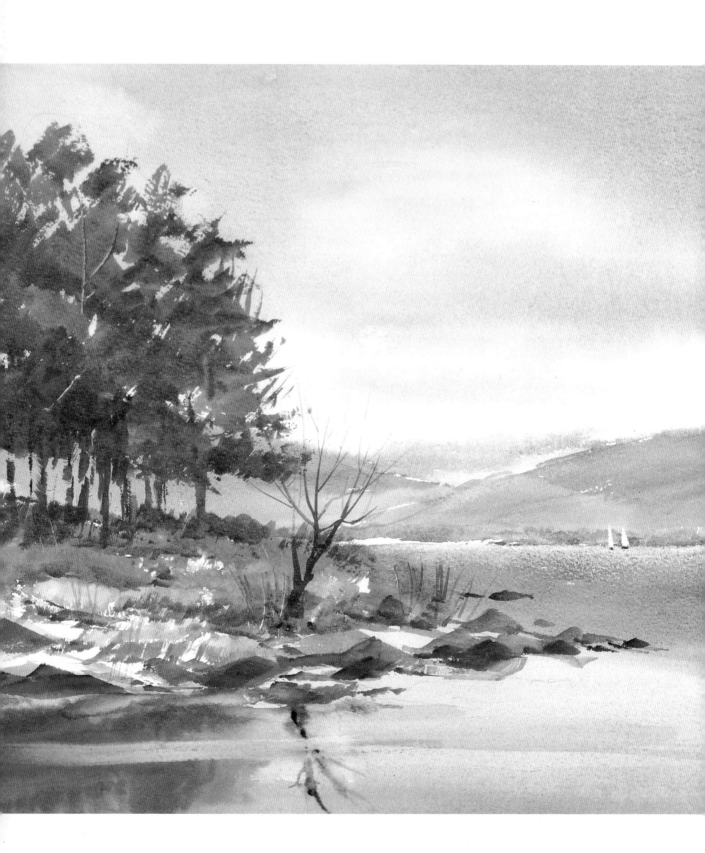

*The composition here is very simple but quite effective and the autumn colours of the tres and undergrowth blend well with the blue grey of the rest of the scene.*

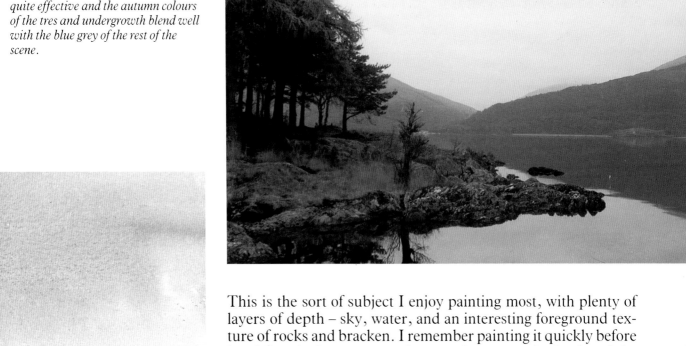

This is the sort of subject I enjoy painting most, with plenty of layers of depth – sky, water, and an interesting foreground texture of rocks and bracken. I remember painting it quickly before breakfast during a watercolour workshop on the banks of the loch, surrounded by about half a dozen early-rising students.

The main change I've made is to try and convey much more sparkle and contrast in my foreground textures. I've also been able to contrast the little foreground tree against the lighter background, and make a more interesting sky.

*In this tonal sketch I lightened the distant hills so that I could counterchange the tree trunks and shadows against them, and added a few yachts – very useful things, yachts!*

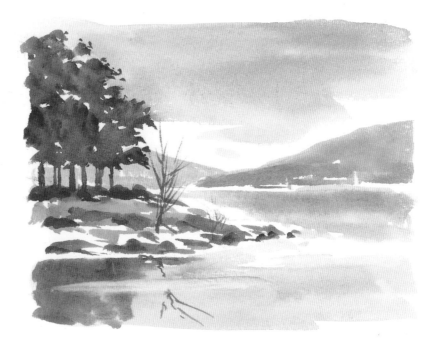

# You're on your own!

Finally, here are seven different projects to have a go at yourself. Study each scene carefully and decide what you want to eliminate and rearrange. Then do a couple of tonal sketches in Burnt Umber or felt markers. When you start painting, try and follow your sketch as closely as possible, rather than the photograph – it might be best to shut the book at this stage and so avoid the temptation to reproduce too much detail.

With each picture I've included a few suggestions on how to tackle it; however, feel free to ignore them if you wish. All I'm asking is that you should try and put into practice some of the ideas we've talked about. The whole purpose of this book is not to show you how to paint from photographs, but hopefully to train your mind to paint any scene in front of you in a freer, more simplified way. The big brushes will help, but the thinking process must start before you even get them out. Before long you will automatically begin to think of ways of extracting the essence of a scene and avoiding the clutter.

What you might find even more helpful is to use my new video, which has been designed to be used in conjunction with this book.

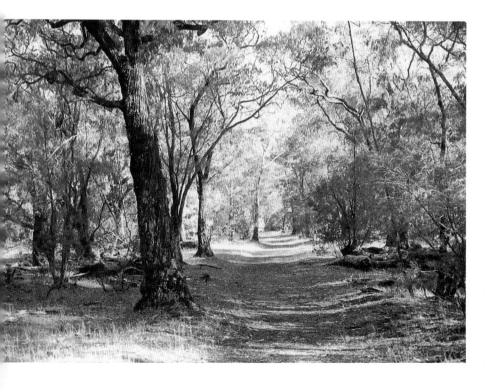

*This is a really hot summer's day in the woods. The shadows are perhaps more important than the sunlit areas in showing this. Your main problem will be to get depth into your picture by perhaps keeping the greens fairly cool and wet-into-wet in the distance, and warming and sharpening them as they get nearer. Remember, don't try to indicate every branch, even in the foreground – leave lots to the imagination; also leave plenty of sky holes. Part of the charm and drama of the scene is the strongly contrasted light and shade, so don't lose it by making your painting too woolly and soft.*

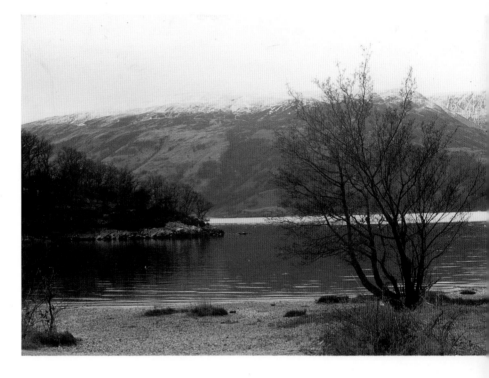

This is a nice simple well-balanced scene to begin with, but if you decide to keep the snow you will need to darken the sky to throw it up. Be very conscious of the three planes – the distant mountains, the island and the foreground shore with trees, making sure you separate the tones more. There's a chance to get some good foreground texture too, but you'll probably decide to leave out the left-hand bush.

There's a lot of sorting out to be done here on your tonal sketch. First have a good close look at the photograph and decide ruthlessly what you're going to leave out – such as the boat poking out of the picture and the chain across the front. Now make sure the buildings counterchange against the background and that the roofs are a different tone from the vertical walls. Perhaps the foreground hut could be shortened on the right so that its profile can be counterchanged against the hillside behind it. The foreground beach needs to be simplified too, with the stones just indicated in a few places.

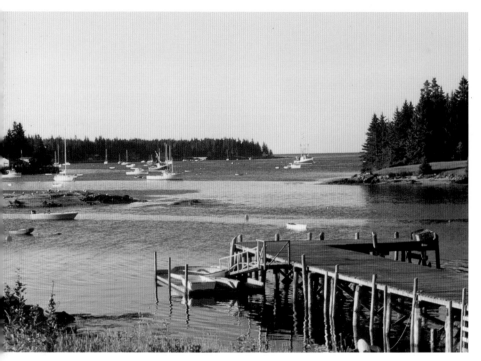

The scene is perhaps a bit too busy to start with, so it needs 'filleting'. Don't attempt to put all the boats in – the little sandbank on the left doesn't help much either. Try and redesign it while retaining the main elements. The tones of the various tree depths should give you food for thought. The most difficult task here is to indicate the water in a fresh and varied way, still showing the white boats. It might be an idea to practise this on a separate piece of paper first.

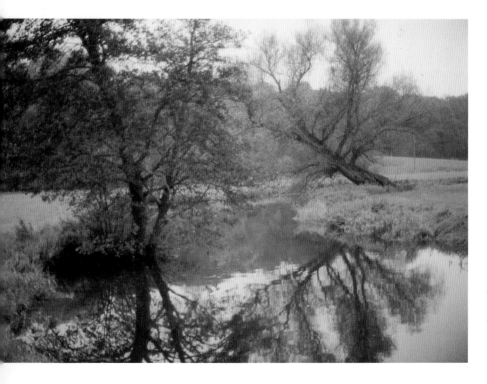

This one's an exercise in depth. In your tonal sketch your tonal values need to be emphasised much more than they are in the photograph – for example even the background woods should vary, the right-hand side being lighter than the left. Make the right-hand tree in the middle distance slightly smaller so that it doesn't compete with the foreground tree – remembering to make its reflection smaller too. In your finished painting, really vary your greens at the bottom left. The sky, too, should have more life and colour in it, which would also reflect in the river.

*This is a real simplification problem, most of it being done on your tonal sketch. Simplify the snow areas and make much more of the road as a design element. There's a super chance here to use simple shadows from the trees to show up the profile of the hillside and road. It could be a very dramatic picture if given plenty of thought beforehand and then painted in quickly.*

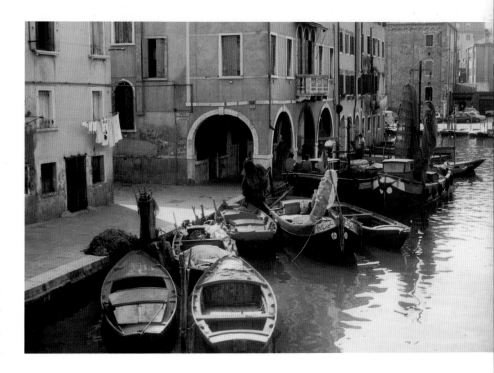

*A completely different problem here but a good chance to put into practice what you've learnt in the chapter on buildings. At the moment both sides of the buildings are too similar in tone and tend to merge into each other, so counterchange much more by changing the light source. Perhaps there are also too many boats and not enough figures. Don't forget to simplify the doors and windows – there's a big temptation to over-elaborate this sort of painting.*

# Index